Advanced
WEDDING PHOTOJOURNALISM

PROFESSIONAL TECHNIQUES FOR DIGITAL PHOTOGRAPHERS

TRACY DORR

AMHERST MEDIA, INC. ■ BUFFALO, NY

DEDICATION

This book is dedicated to the photographer with a passionate heart and an open mind. And to Jane, Gordy, and Bill for forming the constant foundation that gives me wings to fly.

Published by:
Amherst Media, Inc.
P.O. Box 586
Buffalo, N.Y. 14226
Fax: 716-874-4508
www.AmherstMedia.com

Publisher: Craig Alesse
Senior Editor/Production Manager: Michelle Perkins
Assistant Editor: Barbara A. Lynch-Johnt
Editorial Assistance from: Sally Jarzab, John S. Loder, Carey Anne Maines

ISBN-13: 978-1-58428-994-4
Library of Congress Control Number: 200911198
Printed in Korea.
10 9 8 7 6 5 4 3 2 1

Check out Amherst Media's blogs at: http://portrait-photographer.blogspot.com/
http://weddingphotographer-amherstmedia.blogspot.com/

TABLE OF CONTENTS

INTRODUCTION .5

1. A FRESH MINDSET6
Advancing Your Methods6
The Basic Approach10
 Working Unobserved10
 Designing Powerful Compositions11
Changing Desires Require Multiple Shooters13
Educating Clients and Inspiring Trust16
 The Constraints of Photojournalism16
 The Benefits of Photojournalism17
 The Importance of Trust18
Equipment *vs.* Artistry20

2. EMOTIONAL RESONANCE23
Connecting with the Subject's Emotion23
Capturing the Height of Emotion28
Setting Higher Goals32
 Evaluate Your Work32
 Evaluate Your Image Presentations33
 Intensify the Challenge36

3. REACTION TIME *VS.* INSTINCT37
Reaction Time is Not Enough37
Thought Becomes Instinct40
Learning to Anticipate42

4. THE DECISIVE MOMENT45
A Personal Approach45
Henri Cartier-Bresson: The Founding Father45

Speed: Learning to Work Quickly50
Finding the Shot .54

5. PREPARATION56
Preparative Thinking56
Crowds and Distraction59

6. PATIENCE, PATIENCE, PATIENCE61
Learning to Wait .61
Practicing Patience and Preparation:
 The Receiving Line63
The Photojournalistic Portrait65
Striking a Balance68

7. LOOKING AND LISTENING69
Verbal Indicators .69
 "You Look so Beautiful!"70
 "I'm So Glad You Made It!"70
 "That Means So Much to Me!"70
 "Oh My God!"71
Body Language .73

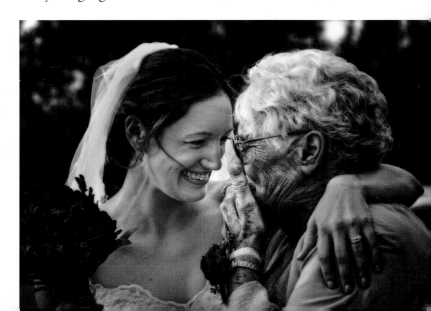

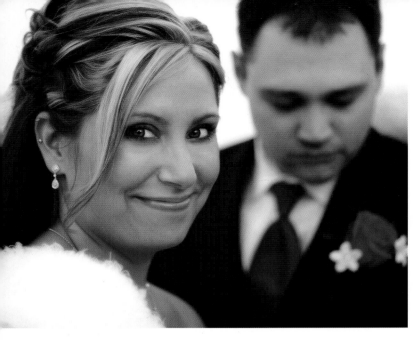

10. Equipment	102
The Digital Advantage	102
Lenses and Subject Awareness	104
Natural Light	104
Pushing the Envelope: Experimentation	105
11. Postproduction and Artistry	107
Monotone Images	107
Losing Extraneous Details	108
Special Effects	110
A Fine-Art Approach	111
12. Increasing Profitability	116
Sell Before the Shoot	116
Timelines	117
Digital Proofs	117
Add-On Sales	118
Gallery-Priced Sales and Presentation	118
Becoming a Member of the Family	120

Traditions	75
Subject Behavior	77
8. Covering Your Bases	78
Genuine Moments and Natural Setups	78
The Bride Getting Ready	82
The Details	85
The Bride's House	86
The Ceremony	90
The Reception	92
The People	92
Available Objects	93
9. Important Characters	95
Parents	95
Children	97
The Extended Family	101

13. A Further Application	121
Children's Photojournalism	121
Distraction	122
Interaction	123
Stimulating Action	123
Customer Service and Sales	124
Conclusion: Educated Instinct	125

PHOTO BY JENEAN MOHR PHOTOGRAPHY.

ABOUT THE AUTHOR

Tracy Dorr, who holds a BA in English/Photography from the State University of New York at Buffalo, has been shooting weddings in a professional capacity since 2003. She is the owner of Tracy Dorr Photography, and in 2009 won two Awards of Excellence from WPPI (Wedding and Portrait Photographers International). For more information, please visit www.tracydorrphotography.com.

INTRODUCTION

This book is dedicated to the photographer who wants to see things a little differently and learn what I call "educated instinct." It is devoted to understanding how you can be more emotionally "tuned in" to your subjects in order to find and capture those decisive moments that make images memorable.

As an established wedding photographer—you understand how to handle yourself and have the expertise that the job demands—I now invite you to take your game to the next level. Great wedding photojournalism is not a casual way of shooting. In most ways, photojournalism is more challenging than traditional photography; it will require painstaking concentration and patience on your part.

This quest to advance our methods begins with asking ourselves what traits a photograph possesses that ultimately make the sale. Are clients interested mostly in the technical qualities, emotional impact, subject content, or finishing style of the photojournalistic image? Or perhaps it's something else entirely—an intangible X-factor captured only when all of these elements come together? Today's clients present us with an increasingly challenging set of high standards. They are more educated and more intrigued by nontraditional techniques than ever before. As photographers, we need to test out our artistic skills and embrace our creativity. Only then can we provide a truly modern and unique product—different than anything that's been provided in the past.

An additional challenge is presented by the fact that the traditional style of shooting, while no longer as lucrative, has not been forgotten; clients now desire *both* styles (posed and photojournalistic) in their coverage. Learning to provide a blend of these very different styles will require some stamina on your part, but it will also have a pleasant payoff: increased sales.

If you want to sell more, you need to learn to capture moments of real emotional resonance—to refocus your intent on capturing moments of interplay between people. The expression of the moment will mean everything to you. We will not be settling for any old candid moment. We will be looking for moments that demonstrate the height of emotion and tell stories in touching and innovative ways. We will be learning to create a piece of art that will last a lifetime for your client—and to increase our sales while we're at it.

This is not a how-to book that will dictate instructions. Books that invite you to follow along step-by-step only help you to achieve a pre-formulated result. The results you will learn to achieve by reading this book will be completely unique because they will be based on your personality. This is a challenge to reinvent your perceptions about your craft and reinvent your work. Throw away traditional conventions. Open your mind to a new experience and get ready to challenge your perceptions about photographing people. We are going to concern ourselves with rejuvenating your shooting techniques. I urge you to accept the challenge.

1. A FRESH MINDSET

This is a photography book that is concerned very little with cameras and hardware. We will not discuss equipment in extensive detail or argue about which lens would provide you with the winning shot most effortlessly. Though we will mention equipment in general and how it can assist you in your quest (see chapter 10), it ultimately will not matter. Certain hardware can help, but wedding photojournalism is a mindset you will acquire; it's not dependent on something you can buy. It doesn't matter if you're still shooting film or if you are a huge advocate of the digital revolution. Once you understand the techniques, and once you learn to see with new vision, you will be able to create more refined images—no matter where you are or what equipment you have.

ADVANCING YOUR METHODS

Photojournalism is not a foreign concept. It is a popular trend in today's photographic market that is quickly gaining momentum. Brides are drawn to it and mothers are stirred by it. So, given that we have demand and we've already started supplying the product, how can we improve it in order to increase sales?

Advancing your personalized brand of photojournalistic photography has to start from within. It's a personal challenge that never ends. On every shoot, while framing every picture, you will learn to push yourself. Accept nothing less than your best, and strive to create work unlike that you've created previously.

Advancing your personalized brand of photojournalistic photography has to start from within.

In order to continue to advance your photojournalism methods, you need to push the boundaries of the style every time you shoot. Create art. Make personal connections with it and communicate with the viewer through each piece. Tell a story and stir emotions in your viewers. Make pieces of art that look polished enough to have been posed.

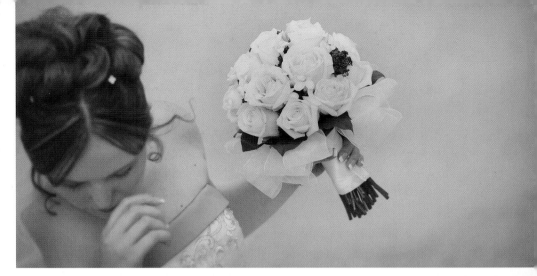

The ability to create a candid portrait that is so polished it presents itself as nearly posed is a tough and elusive skill to acquire. It takes determination and practice, but it pays off. A photo that is clean and skillfully prepared will stand the test of time.

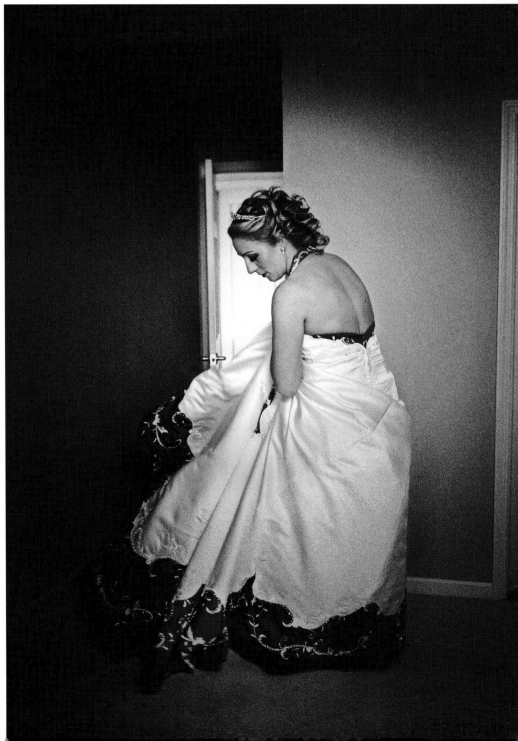

These goals may seem lofty at first, but you'll soon find that they will become natural and instinctive. Advanced photojournalism is all about capturing moments that are fleeting and barely present. Nearly invisible and transient instants of personal interaction punctuate the entire wedding day. They are the type of impermanent experiences that are only caught in a look, a touch, a burst of laughter, or a tear slipping away. They last only seconds but capture a compelling narrative in a single frame—and they can be some of the most moving pieces of art you will ever create.

Because these moments are so brief and immediate, it is difficult to sufficiently describe them in words. It is an indefinable concept. How do we harness, separate, and sort specific instantaneous moments of emotional resonance? Essentially, we have to re-train ourselves to see these moments as they occur. Then, in postproduction, we must learn to apply any enhancements they need to truly shine. By learning to capture a good quantity of quality images and polish them in a unique and individual method, we can try to lay claim to these elusive moments that barely exist.

There are tricks and tools you can use to better your chances of capturing your goals. There is a specific thought process that will help you attain your vision, and there are never-ending sources of intangible, important moments that happen every day, on every shoot. But there is no formula. There are no magic buttons.

We are chasing butterflies with a net. You may have an idea of where they will be and what kind of net it will take to catch them, but you never

I always let intuition be my guide when photographing a wedding in a photojournalistic style. These types of images happen naturally and without warning. You will learn to develop a sense of where to be, when to be there, and what to do in order to best react.

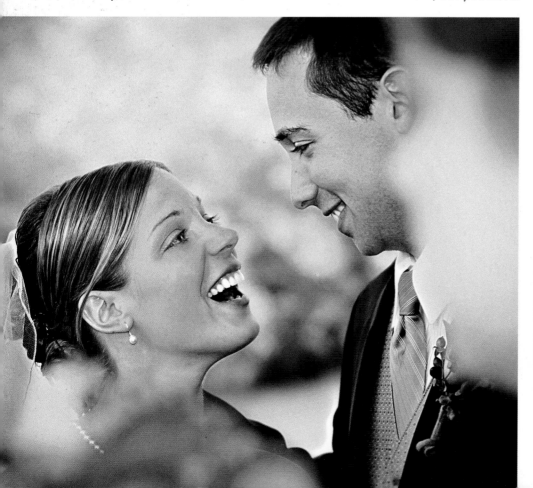

Once you hone your skills, intuition will lead you through a good portion of these types of shots. It will let you know where to be and when.

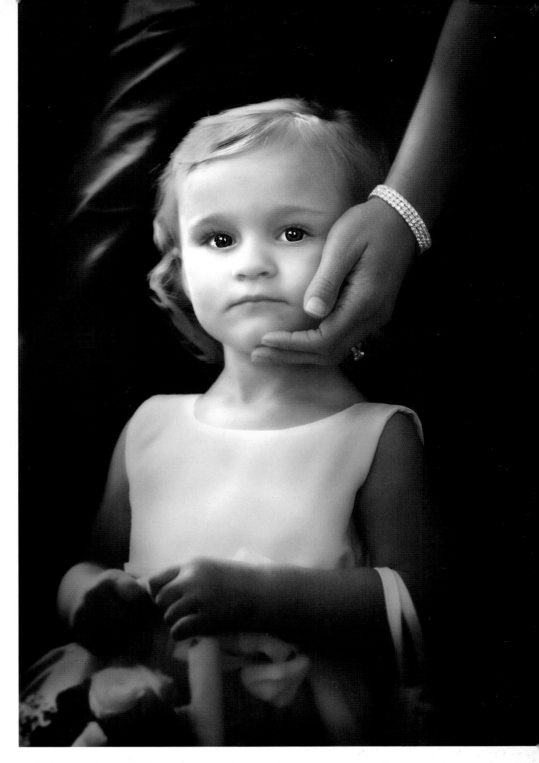

truly know where the journey will take you. You can never really know at the outset what colors and shapes the butterflies might be. You can't even know precisely where to stand when trying to capture them. Ultimately, it will come down to intuition.

Luckily, this advanced method of photojournalism will involve a new intuition—or sixth sense—that you can study. We will learn to embark on a wedding job with no concrete list of what photographs will be taken; we

will trust ourselves to know where to position ourselves, what kind of equipment may help us out, and precisely when to push the shutter. You can become a hunter of advanced photojournalism on the wedding day. Your education starts here.

THE BASIC APPROACH

Working Unobserved. Photojournalistic wedding photography is a rapidly growing trend right now because it is unique to each of your clients. It has an extraordinarily personal touch, since the shots are emotionally charged solely by the individuals and their expressions. You can't duplicate these feelings or isolated moments. The style you shoot in must be completely unobtrusive in order to allow for complete subject unawareness. Only when the subject is totally oblivious to your presence will you achieve genuine, natural expressions.

When humans are aware of a camera in the room, we modify our behavior—even if it's only slightly or subconsciously. The mere presence of the camera changes our reactions and behavior. As a photojournalist, it is your duty to overcome that reaction by blending seamlessly into the background. If your subjects are able to forget you, you'll be privy to the private moments that make photojournalism so important.

Push yourself to honestly practice a total lack of interference—while still creating refined, creative compositions. You'll be surprised what a difference it makes. For example, if you are trying to take the bride's picture and she is standing in front of a bulletin board in the church, try shooting from a different angle that makes the background less noticeable. If you are working at a scenic location and tourists or signs are popping up in the background of your shots, don't accept it! Keep adjusting your position. Keep your feet moving and your eyes scanning until you find an angle that cuts these distractions out. Keep your distance from the bride all the while so that she isn't aware of all of your movement. You never want to be too close. Avoid having her change her actions and the way she is carrying herself. You want it to always be natural.

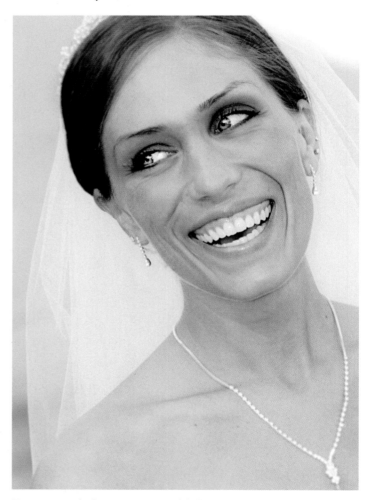

Keep as much distance as possible between you and your subject. Of course, working at a great distance is not always possible—but whenever you can, choose a long lens and blend into the crowd. The less interaction you have with your subject, the more genuine their expressions will be. The subject must be as unaware of your presence as possible or you will encounter altered behavior, however slight.

Once you master the image capture, challenge yourself to go one step further. Get it perfect in the camera as quickly as possible. Here, I challenged myself to get the crop I wanted the first time and didn't crop after the fact. What I saw in my mind was what I shot.

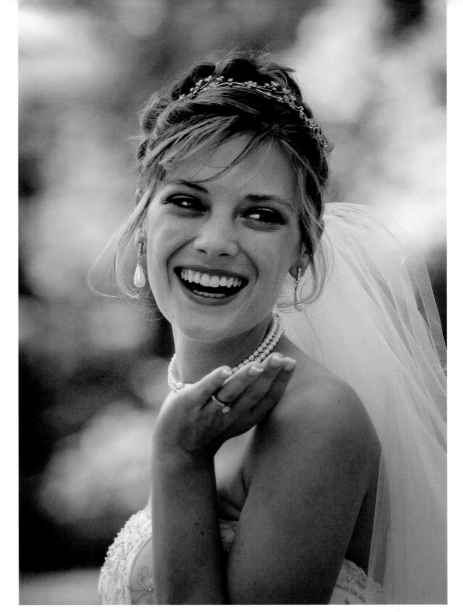

The lack of interaction with your subject is the first principle of modern photojournalism.

Designing Powerful Compositions. The lack of interaction with your subject is the first principle of modern photojournalism. Composing in-camera and being completely aware of what's invading your frame is the second hurdle. I challenge you to expect the best of yourself. Try to get the most simplistic shots you can in a messy setting. Try to crop the image perfectly. Undertake the irritation of trying to find the perfect angle with the least amount of distracting elements.

Above all, shoot for the subject's emotion. Wait for the perfect presentation of them engaging with their loved ones.

Emotion is the key. It will mean everything to the impact of your final image. After all, that's what will ultimately sell a photograph. Who wants a perfectly framed, perfectly lit photo of themselves right before a sneeze? These different stages will all combine to make an impressive array of wedding photographs.

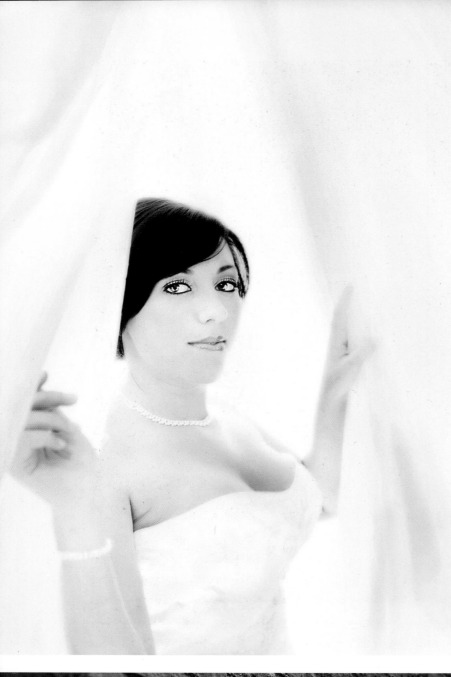

There are two different elements in modern wedding photography: photojournalism and traditional. They work together on a wedding day to provide the modern blend that customers want. You can also take things one step further. Create a few "modern traditional" pieces influenced by what you've learned about photojournalism—relaxed and casual posed portraits that are not purely photojournalistic moments but have some of the ambience of that type of photo. This interesting hybrid of the two styles can yield dramatic results.

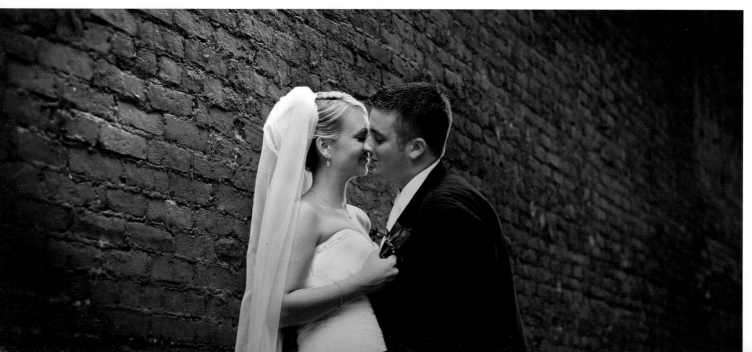

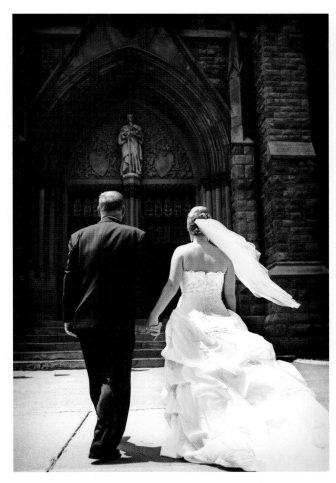

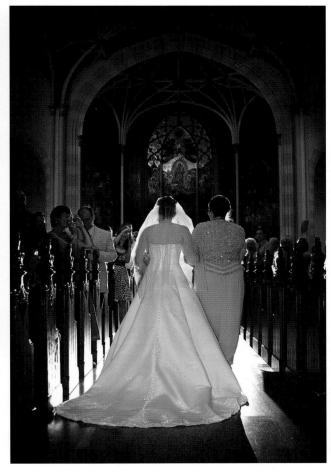

You can't get get shots like these if you are simultaneously trying to get traditional shots of the bride coming down the aisle; you would be in the wrong spot. Having a two-photographer shoot allows you to move about more freely and capture otherwise missed moments like the ones seen above. In the left image, the bridesmaids were already on their way down the aisle. In the image on the right, the bride was making her entrance—and I was able to capture the first photographer's flash into the veil for a dramatic lighting effect. If you provide photojournalistic coverage as a single photographer, you will need to sacrifice most of the traditional shots throughout the day—which is okay, provided that the bride is on the same page.

CHANGING DESIRES REQUIRE MULTIPLE SHOOTERS

A decade ago, most customers hired a single wedding photographer to pose and light them in the most attractive way for their wedding portraits. The photographer was contracted to get a specific set of traditional shots and provide the setup for each. Of course, people are creatures of habit, so demand will always exist for these types of traditional photographs.

Now, however, customers are asking us for more. In addition to the expected shots that we've come to rely upon, they want photojournalism and unusual artistic elements. This is accomplished much more efficiently on a two-photographer shoot. With two photographers on the job, you can satisfy the needs of the client without demanding the impossible of yourself. It is the only way to ensure that you get the conventional photography taken care of while simultaneously blending into the background enough to seek out the moments of real emotional elegance.

The first photographer is the traditional photographer. They are in charge of a long list of must-have photographs that are customary in any wedding. This alone would create a full agenda for one person on one day, but this photographer must also be entertaining and likeable to everyone

Stay out of the "spotlight" to achieve these shots. Blend in.

who attends the wedding. Their personality must come through in a pleasant and polite manner. They'll be "putting on the show" for the clients—cracking jokes, directing people, lending assistance, and giving helpful hints. They'll need to grab everyone's attention. For this reason alone, they simply cannot deliver true wedding photojournalism. How could they take control of a large family photo one minute, then ask people to stop looking and ignore them the next? It's impossible to get true photojournalism when you are also in the spotlight.

Therefore, while the first photographer deals with the list of traditional shots that need to be taken to satisfy everyone involved, the second photographer (the photojournalist) should be completely free to explore the day as it presents itself. Since they have no required photos to take, they will be available to experiment, to move around in an uncontrolled manner, and to seek out the most perfect moments of the day, capturing them in a way that is as emotionally resonant as possible. This allows time for finding

the best lighting and positioning, then patiently waiting for the moments to actually happen.

Ultimately, your customer wants photographs that will remind them and others of the joy of their wedding day. The only way to capture instantaneous moments of real emotional resonance is to be completely free to explore the day for what it is. You can't be preoccupied with anything else. A static picture of a stale smile will not convey the kind of intensity a bride felt.

A static picture of a stale smile will not convey the kind of intensity a bride felt.

Capturing these moments of joy has to be an active process—and being free to shoot anything (with no fear of "missing" something) is critical to developing the uninhibited mindset required.

As a second shooter, you will find yourself excited about drawing out the most sensational photographs you can. You will find that your attitude relaxes and settles in to the pace of the guests. Your only worry will be seeing things from their perspective. This is much harder to achieve when you are worrying over a list of pre-determined photos in addition to the undiscovered ones.

The client should have no expectation as to the quantity of photos the second photographer will provide. If they return with only five photographs—but those five photographs are absolutely stunning—then they've accomplished their task.

Even if you shoot alone, I should note, you can still approach the day with the same uninhibited mindset and provide the bride with stunning photojournalistic coverage. What is required in this case is an understanding

Utilizing a second photographer allows you to see things from the guests' point of view. The drastically different viewpoint is sure to yield results that will both contrast and blend together with the first photographer's traditional shots.

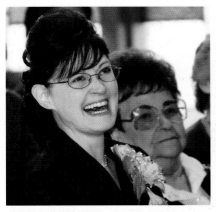

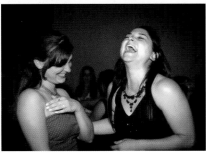

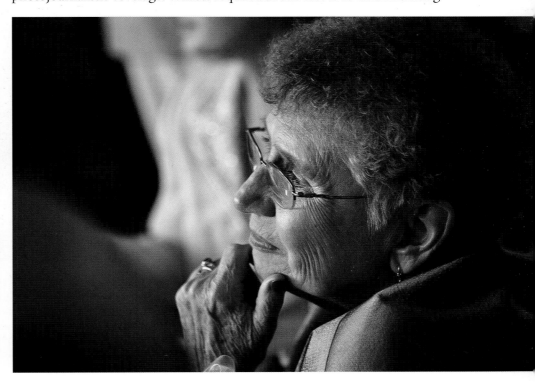

between you and the bride prior to the wedding day. The bride must understand that you need to blend in and that she won't be receiving traditional wedding coverage. If that's exactly what she's looking for—and she understands the constraints and advantages of your style—she'll be happy with the final product. It's important not to bite off more than you can chew by trying to do both styles at once.

EDUCATING CLIENTS AND INSPIRING TRUST

Some clients don't even know they want these newer types of emotional, evocative photos. Modern clients often instinctively gravitate towards them, though. In some instances, they just have a feeling about the types of photos and qualities you are presenting. They may even get misty-eyed or have a sudden response to the samples you show them. To succeed at this style of photography, you will often need to educate your client. Only a bride who fully understands the types of photographs that you are creating will be able to truly appreciate them.

Constraints of Photojournalism. Clients need to study the important constraints of this style of photography. A bride needs to understand that you cannot predict what proofs she will get. When shooting photojournalistically, you can't assure her that a specific shot will be present. You also need her to understand that photojournalism demands her lack of involvement. In this style of shooting, your bride needs to be able to relax and enjoy the day—living in the moment. If she understands those boundaries, she will be able to loosen up as a subject.

Be sure to photograph perishable things like flowers or cakes immediately. Try to find a new and fresh angle to do it. Imagine if you photographed her bridal bouquet at the end of the day. The flowers would be wilted, sad, and brown. It would give the impression of a gloomy and distressing event with little attention to detail. At the beginning of the day, flowers are vibrant and alive, full of the character and ambiance that she has planned for months. They will be a joyful addition to the album you are creating.

That helps you. The first time she views the photos she will be in awe. She will be delighted and surprised by what you've done—especially since she didn't have to micromanage the day and attend to your work.

The Benefits of Photojournalism. You also want your customers to understand that they should be excited and passionate about the product. If they can pick out the unusual elements of your method of advanced photojournalism, they will appreciate their images all the more. If a bride can't identify the difference between a posed photograph and a photojournalistic one, she won't appreciate your work as fully. Similarly, if she can't identify the difference between a stale moment and an emotionally exciting one where the subject is engaged with their surroundings, she will not be able to enjoy this type of image like you do.

By educating your clients you can enhance their response to this type of imagery.

By educating your clients about the personalized richness of your approach, you can enhance their response to this type of imagery—before they even see their own photos. A customer who is as fired-up about these types of moments as you are will be totally in sync with what you are providing for them. That translates into immediate sales and passionate word-of-mouth advertising in the community. The bride will be twice as happy with the product if she understands the value and elusive nature of what it is. This educated attitude can only help you.

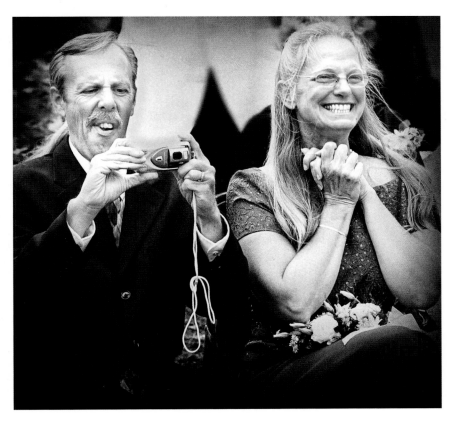

You can not duplicate moments that are charged by expression and story-telling qualities. The way a person moves and the expressions they unveil are completely unique and slightly different every time. The circumstances you are in will dictate the picture—and you can't control that.

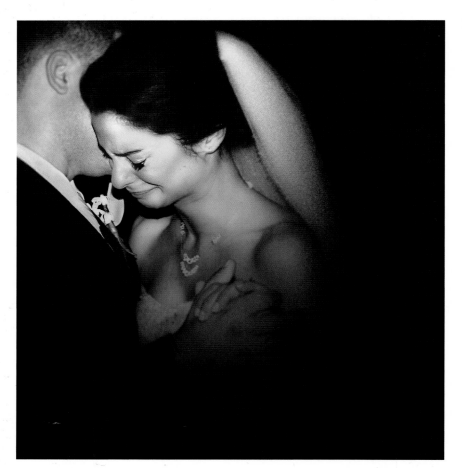

Advanced wedding photojournalism is all about finding new ways to convey the intensity of the feelings the bride is experiencing. It's about telling the story in a fresh new way.

The Importance of Trust. Just as your engaged clients need to be educated before the shoot, they need to trust you enough to be able to relax on the wedding day. The mere presence of the camera affects the way people carry themselves and behave. You need them to discard that attitude. You need to inspire total trust from them, so that they don't spend their time worrying whether or not they look good from a certain angle or wondering if you'll even get the shot.

If your customer knows what you need of them and trusts you implicitly, they will be able to relax and be comfortable about being themselves. Fostering this confidence is a process that starts before the wedding. Remember: just as you require certain things of your clients, they need you to soothe their fears and curiosities about the big day. Spend some time with them. Explain how you work and what types of things you like to do on the wedding day. Answer any and all of their questions. Show interest in their decision-making. Share an ample amount of examples and don't be afraid to be honest—always. The better you know someone, the more you can create photographs that suit their individual personalities.

The examples you have prepared for them are of the utmost importance in this trust-building process. Keep your work current and uniquely mod-

If the bride trusts you implicitly before the wedding even begins, she will be able to relax and loosen her control over the photography portion of the day. She will be herself.

Show your potential clients lots of examples. This will help them understand the service you offer and create appreciation for your work even before the big day. A fired-up and excited customer is ultimately going to be much happier with the product you provide.

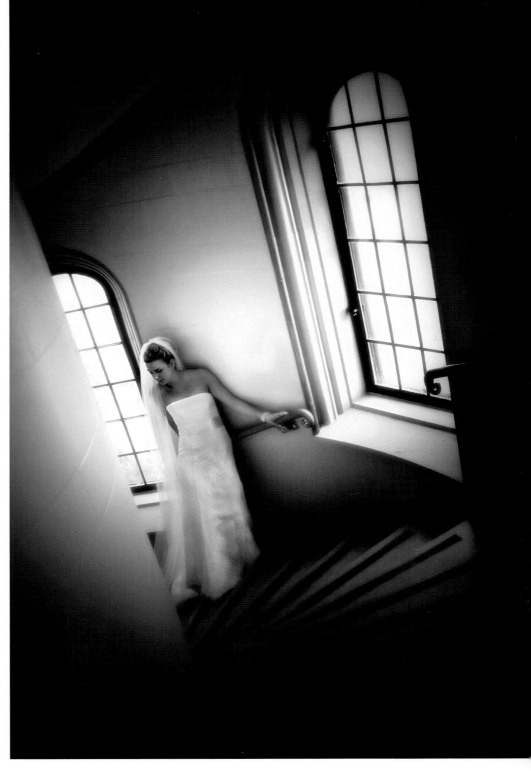

ern. No one wants to see dated or damaged work. That will inspire fear in the client, not confidence. Don't neglect to show them finished, framed pieces in addition to books. The more examples you have at your fingertips, the more easily your points will be understood. Showing a wide variety of images will also demonstrate to the bride and groom that you can handle whatever comes your way.

If the couple connects with your work and your personality, they will develop the trust you need them to have in you and your talent. Once they trust you, you'll have the freedom needed to move about their lives unnoticed. You'll become a part of the day, not a foreign object added to it. Their behaviors will change less than if they are concerned or anxious about your whereabouts. They will be able to put you out of their minds on the big day, which is great for you during the shoot.

EQUIPMENT VS. ARTISTRY

The equipment doesn't make the moment. You do. And it's your eye and your inner artist that's going to make it happen—regardless of all the techno-jargon we so love to indulge ourselves in.

We photographers are a rare breed. We love our equipment almost as much as our children—and we really get excited about minute, cutting-edge changes. We are equipment junkies with few rivals. For a second, though, let's abandon all of our personal photographic idiosyncrasies. Never mind what settings you like to shoot on. Forget all the fabulous new things your newest camera body can do. Just for now, I ask you to abandon your love affair with Canon's newest features and forget the endless battles with Nikon users over quality and mechanics. I don't want you thinking endlessly about aperture or film speed or lenses—because none of that is as important as *your thought process*. You are a capable photographer who can quickly and

It's time to push beyond the basic mechanics of our craft. It's time to challenge the way you see.

adeptly set the aperture and choose your quality settings without difficulty. It's time to push beyond the basic mechanics of our craft. It's time to challenge the way you *see*.

Think back to your first camera body, to the first pictures you ever shot. Remember that beat-up old friend you slung over your shoulder? It didn't matter that it didn't cost thousands of dollars or that it wasn't the newest or best model available. When you first felt the rush of pressing down the shutter button at precisely the right moment, did it really matter what lens you used? It didn't. All that mattered was the fact that you could

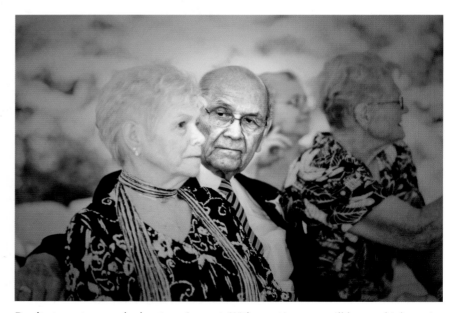

Don't stress too much about equipment. With practice, you will learn which equipment you tend to use most, allowing you to streamline what lenses and bodies you need to carry throughout each part of the day. The less you can get by with, the more mobile you will be.

Begin to challenge the way you consider each photo that you take. Think like a painter. You are choosing the ambiance and mood for each photo that you design. The overall tone that your photo sets is one of the most important elements in this style of photography.

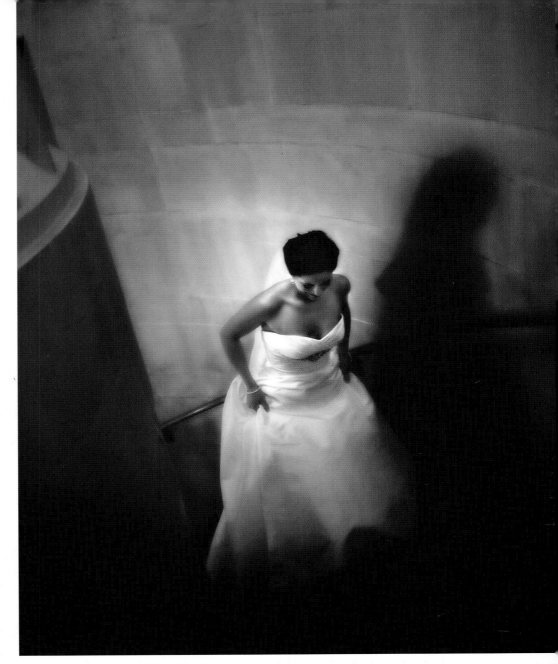

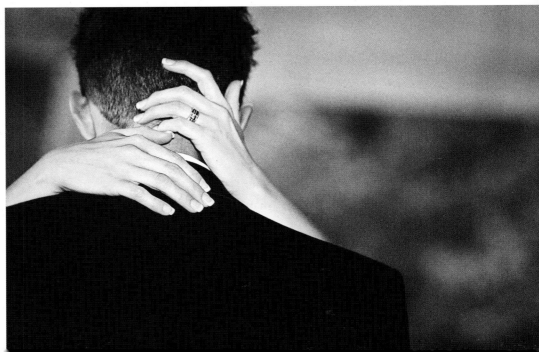

record the moments you saw in your mind and make a beautiful piece of art. As we go forward, keep that mental image with you. Keep that feeling of awe and innocence in the back of your mind, because we will be using that to reinvent our current attitude toward photography. All we care about is the image.

I'm not saying that your exposure and correct camera settings don't have an impact. Of course they do. But, the truth is, a good photograph is a good photograph—regardless of what equipment or settings were used. When someone views the final product, they don't know what means you used to achieve it. The camera is merely a tool; it is the viewer's response to your final image that is key. So, have confidence that you will get the technical aspects of your images right and give more thought to the creative

Make artistic choices that enhance the quality of your work and elevate its status to art.

aspects of what and how you're shooting. Think artistry, not mechanics.

The most advantageous thing you can do for yourself as a photojournalist is to understand the difference between your equipment and your artistry. To do this job successfully, you need a strongly developed inner eye and the patience to keep trying—and keep moving—until you get the exact moment that best tells the story. It is important to think of yourself as an artist, a painter of real-life happenings.

Painters regard their brushes and canvases as the tools used to reflect their creative vision. Photographers, on the other hand, tend to fall into the trap of believing that the camera is doing the work—that we are simply watching and documenting scenes as they unfold before us. Just because our art is based on reality, however, does not mean that the photos we take shouldn't have all the creative and emotional resonance of a painting. Your client will be framing your work and hanging it in their home for decades, and they should have the same feelings of affection for it that they would for a painting that touched them.

2. EMOTIONAL RESONANCE

*P*hotojournalism itself is not a new concept. In order to modernize it, we must concentrate on capturing the absolute perfect moment—the height of emotion that will be the most poignant and engaging of all. We must also look for creative spins on more simplistic shots and edit our images like we're preparing a piece of art for a gallery.

CONNECTING WITH THE SUBJECT'S EMOTION

Advanced photojournalism is all about letting go of the "traditional" wedding mindset. Unlock that artist inside of you; instead of attending the day and recording it, *feel* your way through it. Allowing the shots you take to be governed by how you perceive the events around you. Of course, in order to be successful in selling those images to your client, how you feel has to match the bride's perceptions of the event. You want her to react to your work because it evokes the same feeling in her that she experienced at that moment. This is why it's important to be on the same page as your client. If you are a mile off target and think that what she's feeling is fear instead of joy, then you're definitely not going to sell as much.

The bride, for example, is usually the very embodiment of anxiety. Women spend hours deciding how to do their makeup. They worry over which hair style is most flattering and what dress will make them feel like a princess for a day. As the weeks and months of preparation mount, so do her hopes and expectations for the result. She doesn't just *want* things to be perfect, she is *depending* on things fulfilling themselves in the way she's dreamt of for such a long time. She is also brimming with excitement about seeing her husband-to-be, then declaring their love for one another in front of everyone they know. Essentially, the bride experiences all the apprehension of a makeover, a huge purchase, the fulfillment of a childhood fantasy, and a public-speaking event all at once.

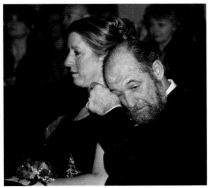

Pictures of people crying can be difficult to shoot. You need to be careful to choose the moment that is most flattering and simultaneously shows the most emotion from your subject. The bride is your main client, and she will want to see their reaction to what was going on—but in a flattering manner. Tissues can create a real problem because they hide the face. Also, certain activities (like nose-blowing) need to be avoided.

Similarly, the groom has been working to make sure that the event goes as well as his bride-to-be hopes it will. He wants to fulfill her hopes and dreams and make the day exciting and enjoyable for all of their guests. He is nervous and excited and filled with just as much emotion as the bride. Don't forget to consider his emotional experience for a moment prior to shooting.

Giving thought to these personal outlooks will greatly enhance your ability to understand when critical moments will occur and why they happen. If you know what an event really means to your client, you will better be able to provide them with the pictures that they want. More importantly, you'll be able to deliver images they will find soul-stirring. The most dramatic pictures will always occur during the moments of highest sentimentality. Those are also the most meaningful and memorable moments of the day.

Of course, all of these things are subject to change. That's the wild, undisciplined nature of photojournalism. You never truly know when or

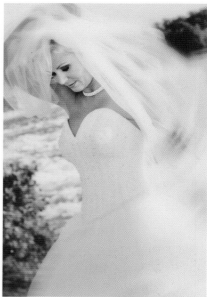

Concentrate on showcasing movement and emotion.

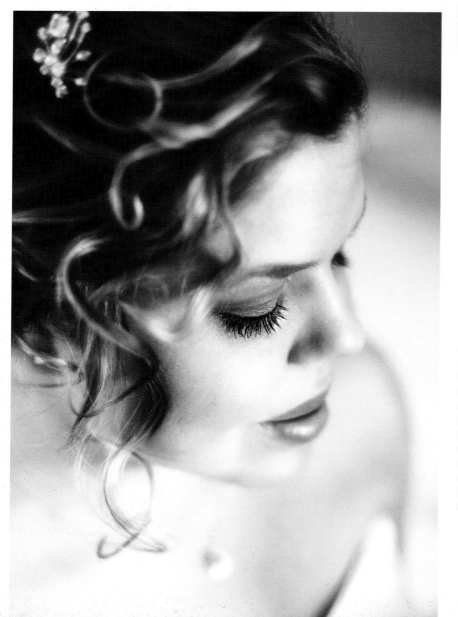

LEFT AND FACING PAGE—The bride is the epicenter of the wedding day. She has spent countless hours preparing. It is your job to figure out how to best showcase all of the little details and choices she has made. Find ways to highlight the importance of the make-up, the veil, and the accessories she selected. Make sure to note particular religious or ethnic choices that she has made, showing her pride in her heritage. These things are particularly symbolic to the bride.

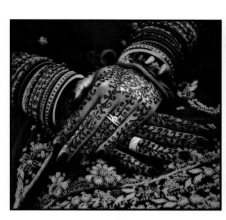
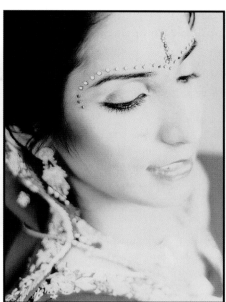
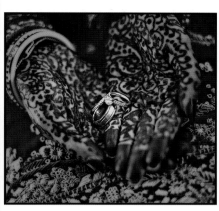

where emotions will overtake someone. One such impassioned moment can occur when the bride and groom see each other for the first time on the wedding day—whether it's prior to the ceremony or when the bride walks down the aisle. You've been trained where to stand and what to look for when photographing this event. You know when to use a flash when not to. But do you know if she will bury her head in his shoulder and whisper in his ear how in love with him she is? Do you think there will be tears? Do you feel her nerves and anticipation?

The old cliché of "walking a mile in another person's shoes" is particularly useful here. Think of this phrase when you're out shooting and remember to put yourself in his or her shoes. Before this "meeting of the

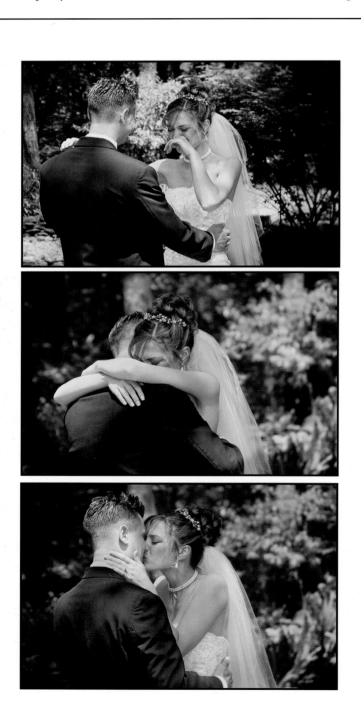

When the bride and groom see each other for the first time that day, emotions will run high. It can be quite touching. Keep shooting. If you end up with a number of good images, consider selling them to your client as a series.

Although the bride commands most of the attention on the wedding day, never forget about the groom. His reaction when seeing her for the first time will be something the bride is extremely interested in purchasing.

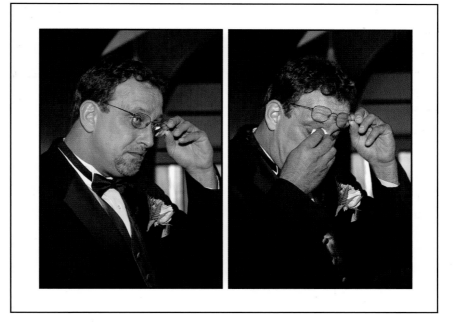

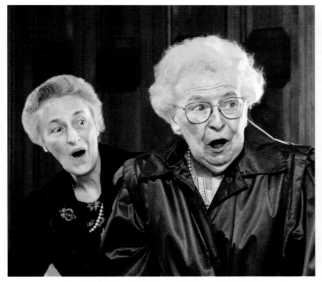

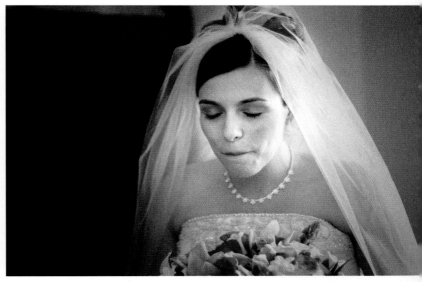

LEFT—The groom's expression is not the only important reaction shot to get during the day. Pay close attention to both family and guest reactions when they see the bride dressed up for the first time. RIGHT—All of the emotions can be somewhat overwhelming for the bride. Pay attention to what she is doing just prior to her procession down the aisle; emotionally loaded moments are very likely to occur while she prepares herself. I added film-style grain to this picture in order to enhance the mood and add a feeling of timeless nostalgia. Being able to decide when and where you want to add this sort of finishing touch is one of the main advantages of shooting digital and utilizing image-editing software.

bride and groom" moment even takes place, you should take a few minutes to yourself to prepare—and I'm not talking about equipment preparation, here. Prepare by closing your eyes. Rid your mind of whatever things are nagging at it. Forget what errands you have to run, forget the rush you were in before you left the house that morning. Forget the squabble you got into with your spouse. Set your own life's drama aside and start to focus

on your subject. The bride is standing there, waiting to see her future husband for the first time on their wedding day—the day that's been in preparation for months, maybe years, and the day that she's dreamt about since she was a little girl. The wedding day cost a small fortune and reflects a multitude of decisions she personally made. Will all of her choices be perfect? Will she look beautiful? Will her hard work pay off?

CAPTURING THE HEIGHT OF EMOTION

Achieving emotional images means not only identifying emotions but also capturing the exact moment that best portrays that feeling. You can't just capture any old moment; you've got to do better than that. You want to be accurate about the perfect moment of joy, happiness, or sorrow—whatever will best engage your audience (in this case, the bride and groom).

When an image is created at the exact height of the subject's emotion, there is a certain level vulnerability on their part. You are portraying them openly and honestly. That moment is as far as you can get from the stale smiles and deer-in-the-headlights looks you often find in formal photographs. It is up-front, visible, and honest. In a moment of purity, you are able to catch the truth about all they are thinking and feeling; you are actually making a study of the human condition. After all, aren't we all wholly subservient to our thoughts, feelings, and emotions? On few other days are your emotions soaring in the way they are on your wedding day.

Photos captured at the height of a subject's emotion carry a huge emotional value and create a unique, specialized product. Make sure you're finding innovative angles and new ways to do this.

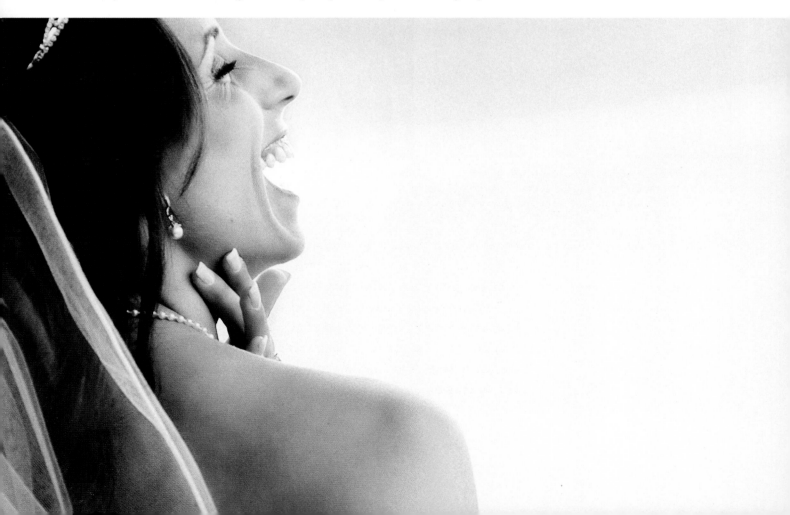

Picking exactly the right moment for your final image will require a great deal of quality control on your end. You need to be selective about the moments you choose. Many moments do not translate well to still images and may end up making an unflattering portrait. I had five different shots of this bride dabbing at her eyes, but I chose this one because you could see exactly what she was feeling.

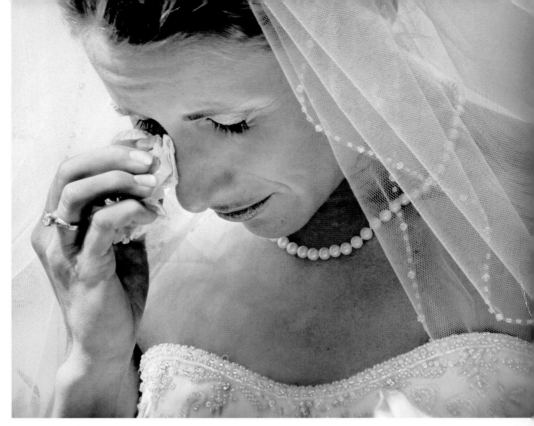

Each moment is unique and different. It is our job as advanced photojournalists to sort them out. Not only must we process the shots after the fact and edit them to suit our goals, but we must constantly be editing and sorting these moments in our minds as we shoot. Knowing which moment, which angles, which lighting will best correspond with our vision is the key element in wedding photojournalism. Which moment is better than another?

When you are practicing wedding photojournalism, you find a lot of "mishap" moments before and after the perfect one. For example, in the seconds before and after someone laughs, their mouth is often open so much that they look like they're baring their teeth to the camera—like they want to eat it. Sometimes they laugh just a little too hard, and it begins to look painful. Alternately, there are those pesky crying shots, when the tears well up and the subject moves to dab their eyes—but then goes for their nose instead! When this happens, you end up with a picture that looks more like someone with a cold rather than an image of a misty-eyed mother overwhelmed by her love for her daughter.

We must constantly be editing and sorting these moments in our minds as we shoot.

The way people move and the reactions they have vary infinitely. It is your job to be discerning and choose the ones that best describe their emotion and their connection to the subject of the day. The only way to know where and when is to develop a sixth-sense about what's going on. If you are experiencing the day in the same way your subjects are, you'll have a

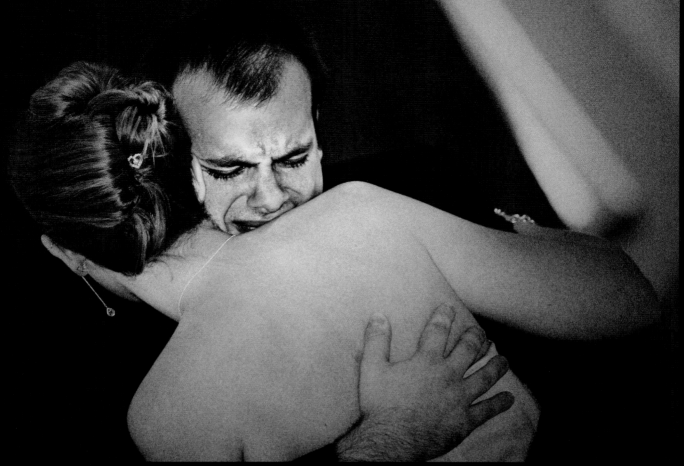

Even though I took several shots, I ended up choosing this particular photo because of the emotion on the groom's face and the angle that best showcases it. You can greatly help yourself by knowing precisely when to press the shutter; the more perfect a shot you can attain right off the bat, the easier your editing job will be. If you shoot only three frames, you'll have an easy job of selection. Some photographers, on the other hand, shoot fifty photos to get one perfect one; that's fine, too, but it costs them time in the editing room. Producing an ample number of images does have one great benefit, however: it will often lead you to work on a series of triptychs or diptychs.

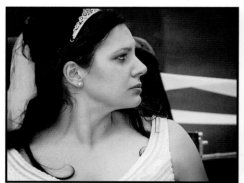

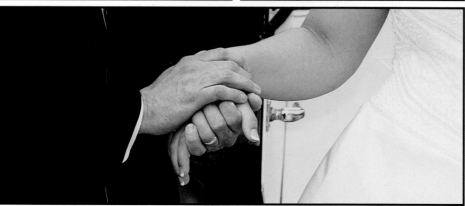

This series was particularly poignant because it evolved a different way than I expected. The bride was overcome with emotion and could not immediately get out of the car and walk into the ceremony. She took several minutes to calm herself before going in. There is a wonderful vulnerability about a person when their emotions are displayed for a moment.

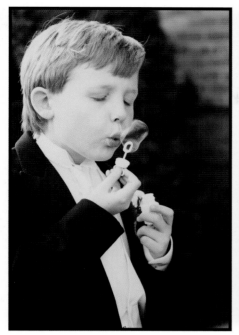

Triptychs and diptychs can feature sequential or related images that tell a story when presented to-gether. As long as the story being told relies on the multiple pictures chosen, it will work. In this case, the series of three shows action. The series of two would appeal to both families and showcases a special moment. Both are valid and unique.

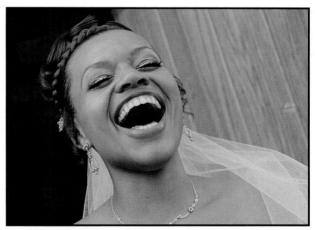

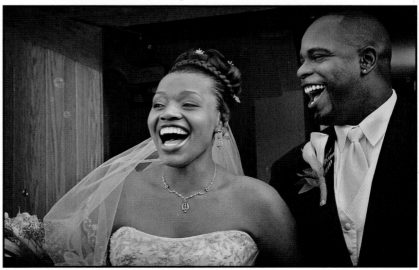

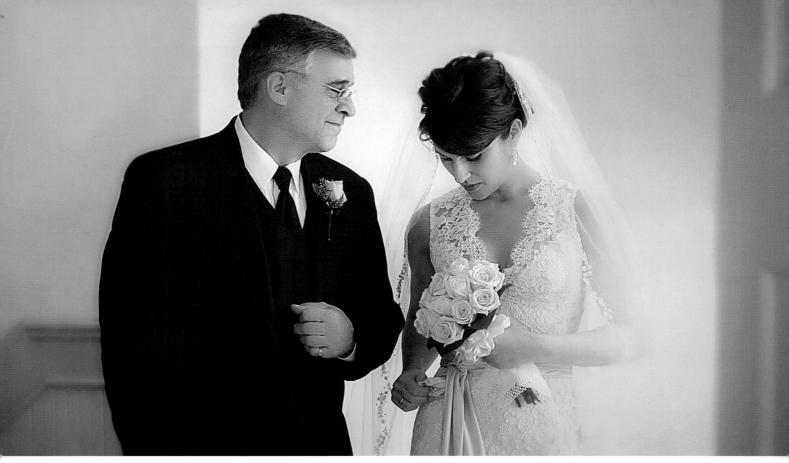

better understanding of them. If you can project yourself into how they are feeling, you'll be experiencing the same emotions simultaneously—not to the same degree, of course, but you will be on par with them at some level. If you are really connected and feeling the emotions of the bride, you'll be poised to anticipate when she is about to cry, or burst out laughing, or heave a sigh of relief.

Moments like the ones we are searching for happen in rapid succession. You will learn to be quick enough to identify them, eventually selecting the perfect one from a group of many. We'll talk more about identifying and capturing the right moment in chapter 4.

SETTING HIGHER GOALS

If we are to push the boundaries of wedding photojournalism, we need to set higher goals for ourselves and aspire to produce more profound images. Beyond that, we need to learn to tell a story in more exotic ways, creating an editorial workflow that helps us achieve this perfect product. Above all, we will constantly search out the moments that reveal the height of the subjects' emotion. Where should you begin?

Evaluate Your Work. Revisit your past work and examine what you can do differently or better. (Even if your past work is just training and not a paid wedding, you can still use that work to gain insight into what you can

Selecting the perfect moment gives photojournalism its impact.

If we are to push the boundaries of wedding photojournalism, we need to set higher goals for ourselves.

do better.) What things do you need to improve upon? Be brutally honest and try setting a list of goals in response to your self-evaluation.

When reviewing your images, look beyond the obvious technical criticisms; taking your game to the next level will require a deeper look at your work. You may be capable of finding the right moment, but are you handling it in a thoughtful and artistic way? Is your lighting dramatic and well suited to your subject? Are your angles innovative and flattering to your subject? Is your equipment limiting you in any way from capturing the image the way it's playing out in your mind? There are relatively few things you have control over in wedding photojournalism. Be sure you've addressed all of the elements that you can control and fine-tune.

Evaluate Your Image Presentations. Once you know how to expertly capture the images, begin to examine how you are presenting them and telling the story of the day. Learn the traditional methods first, then look for ways to rethink, improve, and even revolutionize the craft. How can you smash through the conventional way of doing things and create something more innovative? Usually, this requires breaking a few rules. Some-

Choose the best angle—one that is simultaneously innovative and full of storytelling qualities.

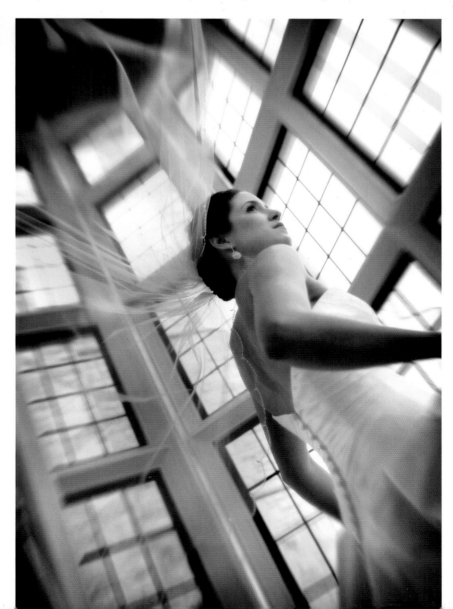

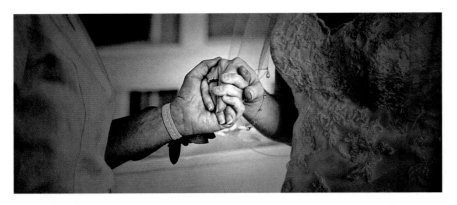

TOP—An unexpected way to tell a story is by showing only the details. Even in a close-up of hands, like this one, you still need to select the moment that has impact and one that has its own expression. Here, the intensity of the mother's hand squeezing her daughter's hand shows affection, nervousness, and excitement—even without seeing their faces. It is not enough to simply take a picture of their hands; it is the level of engagement that communicates the impact. These shots are more subtle than their portrait-based counterparts, but they have their own unique qualities and help to round out a finished album, showing that your company goes above and beyond. BOTTOM—Embrace change and learn when to try breaking the rules in order to push the boundaries of your style.

times it just requires bringing a new outlook to something we've seen a thousand times. Developing a new style of storytelling is all about embracing change; adopt an avant-garde attitude and eliminate any and all boredom that comes with the "oh I've seen that before" attitude many photographers develop after seeing dozens and dozens of weddings. Shoot for impact and your own new style.

We should always be mindful of telling the story in different ways. Typically, a single image of extreme impact is chosen to tell the story, but you

Sometimes photos tell the story far more effectively in sets of two or three. They rely on each other for importance and impact.

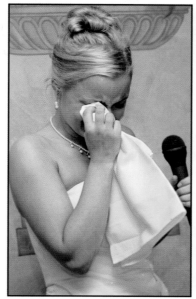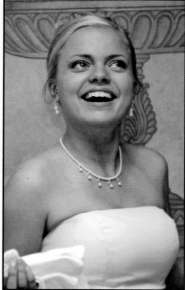

When artfully matted together

as a series, the images take on

a storytelling quality.

should start to familiarize yourself with the concept of diptychs and triptychs to give yourself more options for creativity. Diptychs (a series of two related pictures) and triptychs (a series of three) are not new concepts. Two or three prints matted in succession can show a progression of events, enforce the repetition of one image, or add an unseen element of challenge. Most commonly, you would find a selection of prints that shows movement by the subject. Since photographers tend to overshoot (especially in the boundless world of digital photography), creating multi-image products like these can help make the mass quantities of images we create work to our advantage. You may take fifty shots to get one. Or, if you look a second time, you may find two or three in that fifty that tell the story and are stronger together than individually. This is particularly important in triptychs depicting movement. Don't start deleting your files until you are sure that there aren't second or third options that may enhance your product.

We can also use this style of production to enhance images that would be less meaningful on their own. For example, candids of each member of a family on their own are nice, but when artfully matted together as a series, the images take on a storytelling quality. That family's bond becomes the subject. Matting them together enforces the bond between the individual members, and the grouping of all the pictures together gives each individual picture more merit. Working together, they are stronger than they are apart. Seeing different images side by side forces the mind to draw stronger connections between them than it otherwise would.

From a customer's standpoint, people often prefer one finished piece to hang on their walls rather than tons of smaller ones sitting around that begin to look like clutter. A larger, more polished, framed collection of photos demands more respect and worth from the owner and the viewer alike. It demands more attention and commands more significance just by being larger and higher in quality.

Since we are thinking of our work from an advanced and artistic standpoint, we need to begin concentrating on creating high-quality finished products that can be showcased in people's everyday lives. Think of producing art, not merely pictures. Give your work lasting resonance by making it impressive. (*Note:* Before you mat your work, you will need polished images. Streamlining your workflow can go a long way towards making this an efficient process. We will talk about editing techniques in more depth in chapter 11. Overall, though, you should bear in mind the importance of editing on the look you are trying to create. The image comes first, but the editing can really make or break it for you.)

Intensify the Challenge. In case these things don't present enough of a challenge for you, the final step in advancing your craft can be the in-camera challenge. Try to go out on a wedding and get every shot right in the camera. While being mindful of impact, emotion, lighting, and angles—as well as subject relations and interactions—try to crop in-camera perfectly and get everything just right in as few shots as possible. Think like you did during the film era. In this challenge, files are non-disposable and you have limited options afterward. See if you can get the images you want with as little waste as possible—and get them right the first time to save yourself editing.

A great way to create a triptych is to have it custom matted. In this set, I matted each member of the family together in order to signify the family bond. It also creates a finished piece with what otherwise would not have been a group sale.

3. REACTION TIME *VS.* INSTINCT

*O*nce you really hit your stride as an advanced photojournalist, you will find that knowing when and where to be becomes almost second nature. Weddings are repetitive by nature; the same events usually happen at every event, and most of the emotions people experience during the day are rather similar. The traditions they choose and the locations they have available will become highly familiar to you over time. This is helpful for you as a photojournalist, because it will make it easier to develop an inherent sense of "where" and "when." You'll begin to instinctively know who to follow around and where you need to be at what time during the day (since you'll know what times of the day are particularly powerful for the participants).

Do not misunderstand, though; this is in no way foolproof. Photojournalism demands an understanding of one rule: there are no rules. All people are different and no behavior is ever truly reliable. But over time, you'll find that you do begin to operate in a subconscious way—and imagine the power you will find as a photographer when your talent becomes linked to this sixth sense. No longer will you just be creating strategies and recording situations. When you reach this level, you aren't just reacting; you are being. All it takes is a change in attitude and a little mental preparation. Follow that up with your usual equipment preparation and you'll be a fantastic photojournalist.

Photojournalism demands an understanding of one rule: there are no rules.

REACTION TIME IS NOT ENOUGH

Perhaps the most important thing to remember about advanced photojournalism is that if you want a product that has the timeless resonance of a piece of artwork you cannot simply rely on reacting to what's happening around you. It's not good enough. You need to be prepared and to anticipate, as much as possible, where and when *the* moment (not just *a* moment) might happen. If you just wait around to see what happens,

you'll likely be on the other side of the room when you hear a gleeful "I'm so happy for you!" and see a hug that turns into a lasting moment. You'll be too far away or on the wrong side of the person. If you were close at hand and paying attention to who was about to walk by, you'd be able to better identify when two important people are about to intersect.

Of course, there are no hard and fast rules. No matter how you prepare yourself, there are no guaranteed reactions, and therefore no guaranteed shots. What I am highlighting is the idea that you have a complete under-

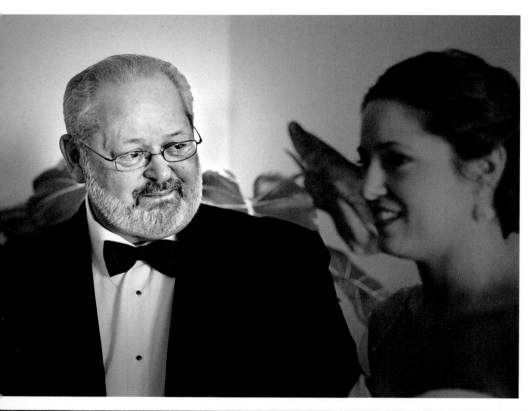

Each of these photographs tells a story about the subject by relying on the message conveyed through the expression in their eyes.

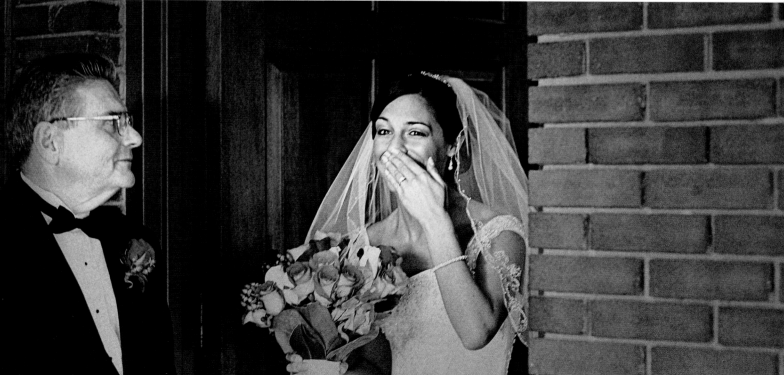

Get ready to move. Don't wait for a moment to happen near you. You may have to move quickly and anticipate things.

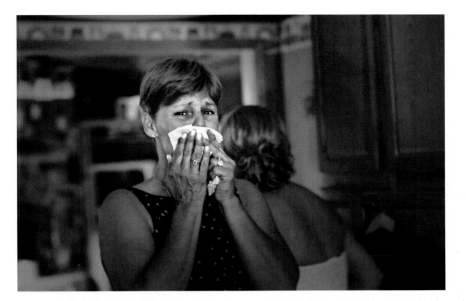

standing of your subjects and what might happen. This comes back to the theory of "feeling the day out," which we discussed in chapter 2. We need to pay attention to what our subjects are thinking and feeling. It is not enough to just see what is going on; you have to understand it and internalize it. If you do that at every wedding, over time you will develop a sixth sense about what is happening, when, and why. This allows you more preparatory time to anticipate the likely movements and reactions.

Some of my most memorable shots were captured because I was able to anticipate the event.

Some of my most memorable shots were captured because I was able to anticipate the event. In my mind, I wasn't just going through the motions. I was there in the moment—in sync with the subjects and instinctively aware of what was important about the situation. I was prepared with the right equipment, my eyes were on the subject's face, and my cam-

era was up and ready to shoot as soon as I recognized the moment. I prepared myself both mentally and physically. My mind was not on what was for dinner or the car problems I was having. It was locked in the present moment.

THOUGHT BECOMES INSTINCT

You now have an idea of some of the thoughts that are running through your subjects' heads. Can you feel some of these emotions? Is the excitement just as palpable to you as it is to them? In order to feel the moment and turn it into art, it needs to be.

Let's return to considering the moment when the bride and groom first see each other on the wedding day. This is a moment when a million thoughts and emotions are colliding and racing through the bride's head. As the groom comes in, be prepared for an appropriate reaction to all of those feelings. If you instinctively know and understand the subject's state of mind, your hands will respond and make the moment as great as it can be. Your body will react more quickly to your own instinct than it will process your observation of a subject's reaction.

I was ready to go in every respect, so I was able to capture the depth of the relationship between these two women. I knew how excited the bride was and that she hadn't seen her grandmother yet. I was focused and in the moment. I prepared everything as best as I could—I had just changed my memory card and put on a long zoom lens—and I moved around freely to select the best angle.

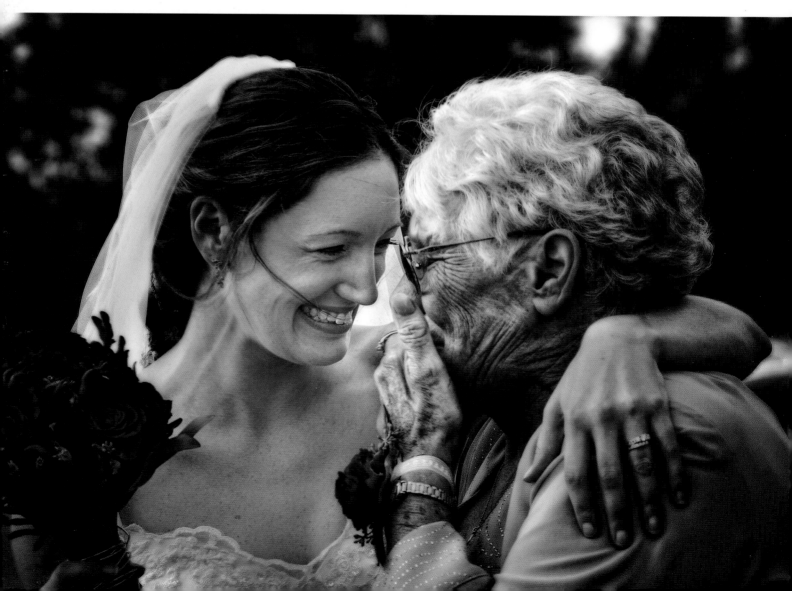

Right before the ceremony, the bride's emotions show quite plainly. Pay attention to subtle looks and gestures. Stay as out of the way as possible and let the situation unfold in front of you. Remaining essentially invisible to your subjects allows you to capture honest moments that aren't tampered with or changed in any way.

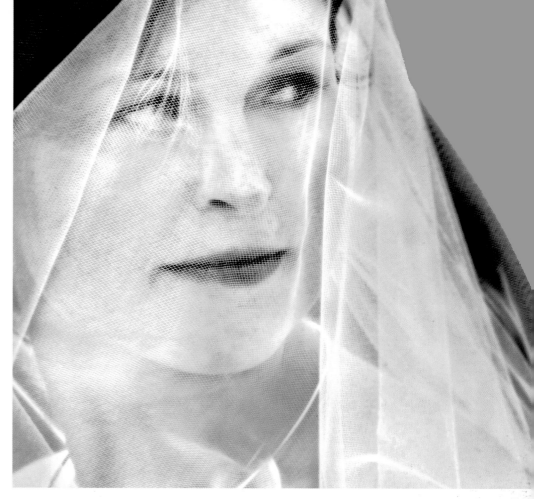

It can be a bit hard to keep

photographing with watery eyes.

But you'll get used to that.

For example, you'll know a few tears are imminent in this bride-meets-groom situation, as is an immediate and long lasting hug. Be ready for both of those things. Be ready with a long lens so you can afford them privacy, which will draw the moment out even longer. Give them space to tell each other everything they want to, and be ready to capture those expressions as they happen. You will know when to expect a great expression—and be able to react instantly—because you are putting yourself in their shoes and intuitively grasping how things must feel from their point of view. You know how you might react, so you should have a pretty good idea how they might behave, too.

You may even be experiencing their emotions simultaneously. There have been many moments when I was photographing a bride or groom saw them begin to cry. Of course, I began to tear up a little, too, because I knew what they were thinking and I was in that place with them. This meant that I knew exactly what reaction was coming and how I wanted that moment to look. I prepared for the moment and I was ready to capture it. I was anticipating it, not simply reacting to something that was already happening. It can be a bit hard to keep photographing with watery eyes. But you'll get used to that.

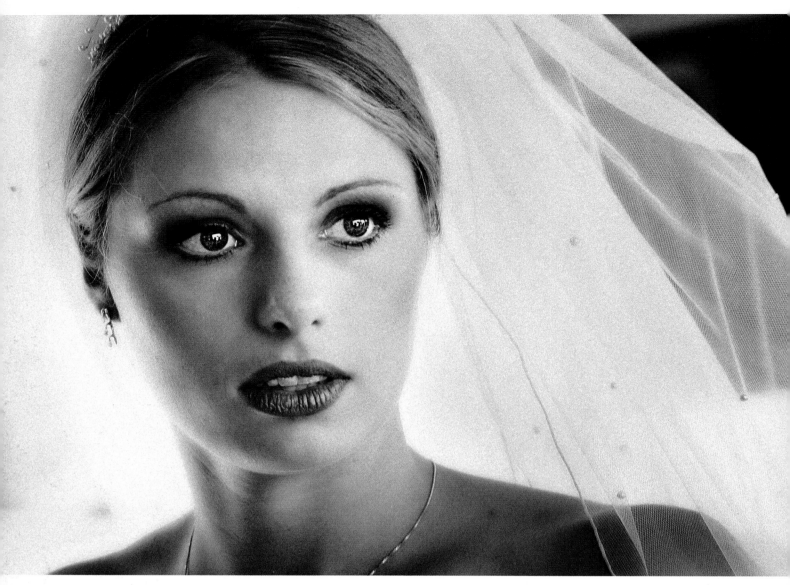

LEARNING TO ANTICIPATE

How do you learn to do all of this? How do you tap into your empathy for strangers you know little about? Just dive in. Take some time to clear your thoughts and project some of their feelings onto yourself, as we discussed.

Beyond that, get out there and start to practice. See if you can tag along as an unpaid assistant to a traditional photographer. If you aren't being paid, there is no worry about having to produce anything, so you are free to learn to seek out the moment.

If that isn't an option, take your camera wherever you go. Events with crowds are good practice for a wedding. People are in conversation and constantly moving. Since strangers may be nervous about having you photograph them, your own family gatherings can be an even better option— it might be time to invite a bunch of relatives over for a barbeque. If you

Try to put yourself in her shoes. This shot was taken as the bride entered the church for the first time. I asked myself, "What is she going through right now?" and tried to pinpoint an answer in a single expression.

This photo was shot prior to the ceremony and seemed to encompass all of the emotion and nervousness that the bride was feeling at the time. Sometimes a solitary look or gesture tells the whole story.

are invited to a wedding, take your camera and practice shooting. Try to be someone's date for a wedding where you don't know anyone.

Whatever you can do to get yourself out there is more than okay for training purposes. Wherever you are, whether it is out for coffee or shopping at the grocery store, train your eye to start looking at people and reading their reactions. You don't even need a camera to get started. The first

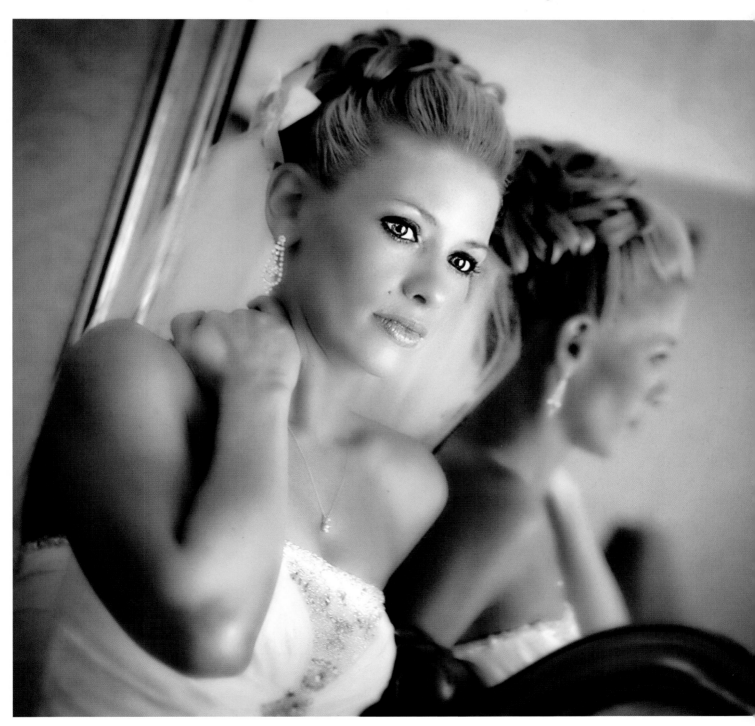

step is learning to read people's body language and behavior. Then, find a way to put your skills to the test and start training your fingers to know when to shoot. Experience is everything.

The bottom line is this: it takes time to gain the experience required to do this. Be patient—and don't be shy.

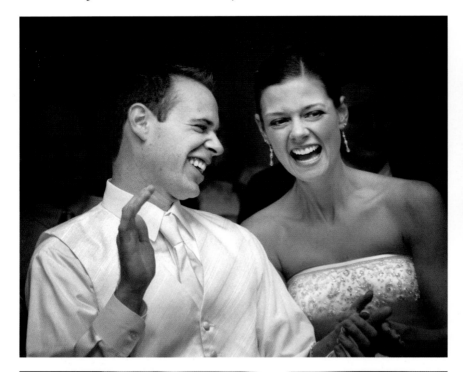

Any time you are in a group setting or in a crowd, use that as practice. Really utilize these moments. They provide ample opportunities for you to hone your skills and the result will be great candids.

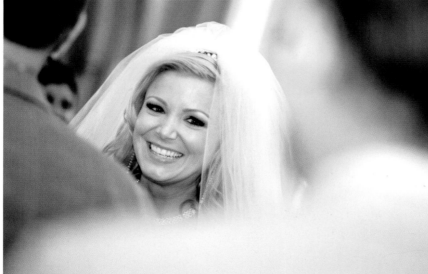

4. The Decisive Moment

The decisive moment is the moment where every element of the photograph works in unison. It is the instant of peak action or emotion that stands out from all the other mediocre moments that come before and after it. The decisive moment is completely filled with impact—I cannot overemphasize that. Images that capture the decisive moment have a unique ability to affect the audience and tell a story. But how do we tell one moment's value from another's?

A Personal Approach

When photographing people, the decisive moment occurs in a fraction of a second and paints a portrait of a person's life; it reveals a bit of their true personality. In this moment, a rich complexity arises from the interplay of what the subject is feeling in that instant and how that feeling is interwoven into their entire life. It is a portrait of their innermost self being exposed, if only for a second.

When we attempt to isolate one moment that will create a portrait of someone's personality and emotions, our success is contingent on the precision of our selection—which second we choose. The decision about when to push the shutter button must be made with a significant level of intelligence, understanding, and careful thought.

The decisive moment occurs in a fraction of a second and paints a portrait of a person's life.

Henri Cartier-Bresson: The Founding Father

The concept of educated instinct is useful for teaching your mind to instinctively prepare for and react to the situations you are capturing in your images. If there is one founding father of this concept in photography, it is Henri Cartier-Bresson, who spent his life seeking out those decisive moments. By doing so, he created a new understanding of this branch of photography. Bresson's approach to this technique is essential to understanding the type of emotional photojournalism that we are ex-

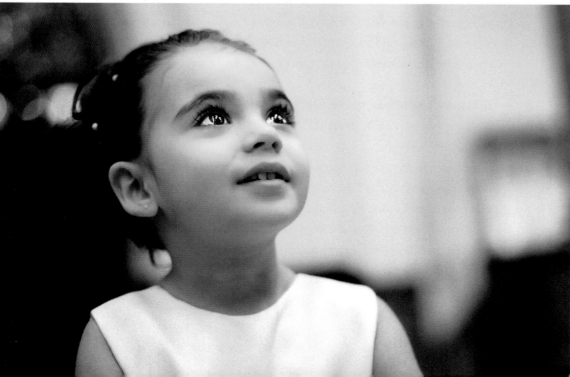

Let the subject's expression drive both your picture-taking and your final product. Keep it simple. In particular, try to capture the eyes. They are the most expressive feature at any age, but particularly with children.

ploring. In *Henri Cartier-Bresson: Photographer* (Little, Brown and Company, 1979), Cartier-Bresson wrote:

> "Manufactured" or staged photography does not concern me. And if I make a judgment, it can only be on a psychological or sociological level. There are those who take photographs arranged beforehand and those who go out to discover the image and seize it. For me, the camera is a sketch book, an instrument of intuition and spontaneity, the master of the instant which—in visual terms—questions and decides simultaneously. In order to give meaning to the world, one has to feel oneself involved in what he frames through the viewfinder. This attitude requires concentration, a discipline of the mind, sensitivity, and a sense of geometry. It is by great economy of means that one arrives at simplicity of expression. One must always take photos with the greatest respect for the subject and for oneself.
>
> To take photographs is to hold one's breath when all faculties converge in the face of fleeing reality. It is at that moment that mastering an image becomes a great physical and intellectual joy.

We are documenting a moment, but we are also examining the complexity of human emotions.

None of what he writes should be taken lightly when shooting in this style of photography. He is describing exactly the thing that we are seeking, the type of photography that literally reveals personality. The resulting photograph releases information about the subject in psychological terms. We are documenting a moment, but we are also examining the complexity of human emotions—and, on a higher level, portraying the essence of the human experience. The decisive moments we are discussing in this book capture the raw emotion of a person. The camera is merely the tool by which you can become completely involved in the moment your subject is experiencing and record it.

In the introduction to *Henri Cartier-Bresson: Photographer* (Little, Brown and Company, 1979), Yves Bonnefoy writes:

> Technique is, for Cartier-Bresson, only a means, which he refuses to aggrandize at the expense of initial experience, in which the meaning and the quality of the work are immediately determined. Of what use are shutters of different speeds, papers of different sensitivities? They attain

levels of perceptible reality—for example . . . a fleeting gesture or expression, or the lovely texture of skin or fabric—that could not be detected without their assistance.

Bonnefoy is highlighting an important point in this style of art. It does not matter what technical means you have at your disposal, as long as they are sufficient to capture the image in a quality manner. What is truly important to remember is your instinctive understanding of what Bonnefoy calls the "levels of perceptible reality" that we are seeking when shooting this way. I would propose calling this approach "instinctive photojournalism." The awareness that you are developing throughout this book will eventually become second nature to you. It will be a sixth-sense style of photography that you initiate when you want to create the type of timeless, instantaneous portraiture that photographers like Bresson also sought to produce.

To shoot in this style you must be sharp, intelligent, and—most of all—fast. In the same book, Bonnefoy further clarifies the actions needed, stating that success relies on whether or not "[. . .] he who holds the camera can move into action almost as fast as the shutter, can surrender to intuition, can pounce like a wild, stalking animal on what moves with lightning speed." The metaphor he suggests is a valuable one. Think of instinctive

Don't worry if you don't have the latest camera or the most expensive lens. Provided that your equipment's level of quality is adequate for the job, the expression you capture is far more important than the tools you use to capture it.

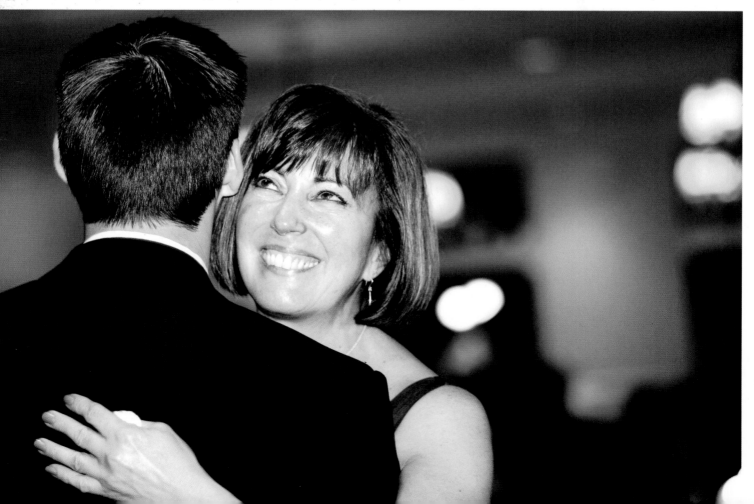

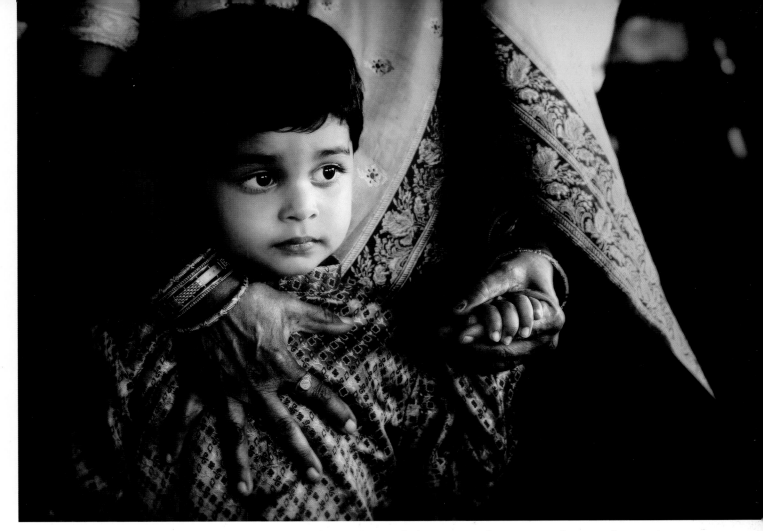

This type of shooting happens extremely quickly. This shot was particularly important for me to get because there was a lot of movement going on—and this moment lasted only a second. Conditions are constantly changing and the slightest movement may make or break the photo. If you are even slightly off, it won't work as successfully.

photojournalism as a hunt. You are the hunter, seeking out your prey—but you are also thoughtful and selective about what subject you choose and when you choose to take your shot. If you seek out your subject with that kind of dedication, you will inevitably see a great deal of progress in your work. You will start to see the hyper-reality that we are trying to create and you will understand when to attack it.

You are the hunter, seeking out your prey—but you are also thoughtful and selective . . .

By presenting this material from Henri Cartier-Bresson, I am not suggesting that you try to emulate his work. I simply hope that with a more careful understanding of where the "decisive moment" concept started, we can enhance our own brands of photography based on instinct and emotion; we should always avoid comparison or reproduction. You should use the work of great photographers to inspire you to create highly charged emotional images that are unique and contemporary.

With this concept in mind, we can learn to anticipate, prepare for, and recognize the decisive moments that will define a new style of shooting.

SPEED: LEARNING TO WORK QUICKLY

The decisive moment will pretty much always happen shockingly quickly. Most moments will occur so quickly you almost miss them. To make matters worse, if the subjects are totally unaware of the photographer's presence (which encourages the types of spontaneous interactions you want to capture, as we discussed in chapter 2) there's a good chance they will be moving around a lot, obscuring your chances even further. Additionally, things will often happen next to you or behind you, so you'll need to be ready to move at any time. To achieve the perfect selection of the perfect angle amidst all of these challenges in a fraction of a second, you'll have to be ready and on point.

Wedding photographers were traditionally dedicated posers of individuals and groups, allowing ourselves time to pose and re-pose whenever necessary. It wasn't necessarily slow, but we weren't asked to be ready in a split second, either. Shooting photojournalistically, you will need to increase your reaction time, your tempo of shooting, and the speed at which you can move your body to the right point. Even if you can see a moment happening, if you can't get your camera in place and focused quickly enough, you will miss it. If you shoot from the wrong angle because you were off by two steps, then you won't get the optimal shot—the shot that will make your work really stand out. You need to be mobile at all times and never lazy about moving your feet quickly to get into place. Additionally, focusing and shooting quickly have to become second-nature skills for you.

What can you do to practice? Before you ever get to a wedding, be sure you are a master of your equipment. There should be no lag time on your part. Things like autofocus, which seems so easy in theory, can become a big problem when you're in changing lighting situations with groups of moving subjects all around you. There needs to be no hesitation, and that only comes with practice.

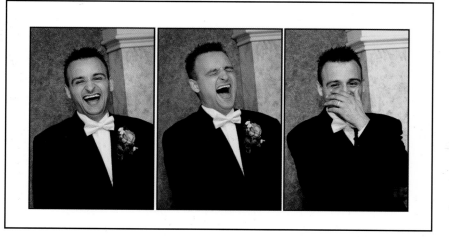

When shooting photojournalistically, moments often unfold ridiculously fast. You wait and wait—then snap the pictures in a matter of seconds. Be ready at all times and keep shooting. You never know if a series of the same subject will be stronger as a triptych, like this one.

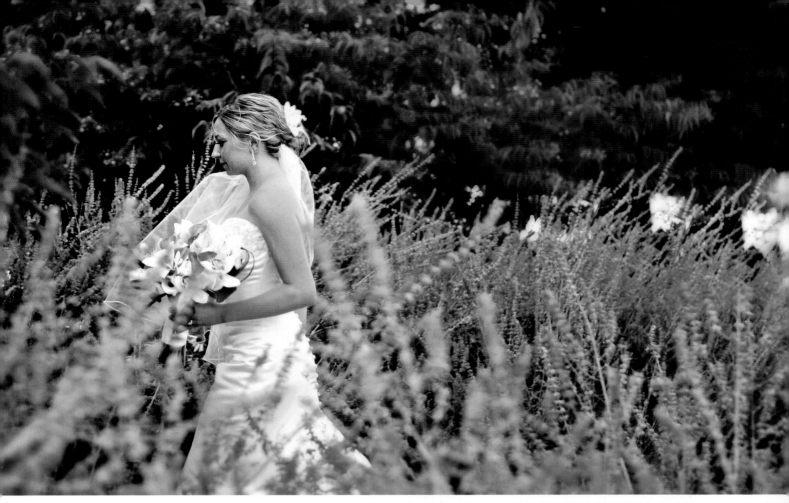

Learning to create images like these took years of practice on my part. I had to learn where to be and when to shoot, usually having only a second—or less—to grab the shot. The best way to start is to practice. Then practice some more.

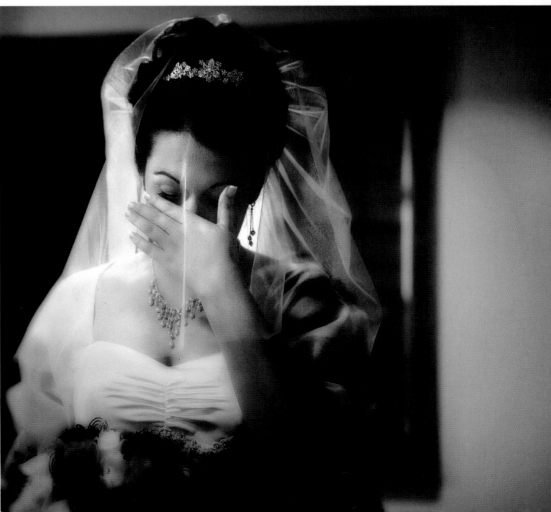

LEFT AND FACING PAGE—You will develop your selection skills as you gain experience. In order to find the perfect shot, decide what function your photo is providing. Is the image driven by the expression of your subject (left)? Or are you looking for a more avant-garde image that you can add an effect to and have a more artistic result (facing page, bottom)? The image could also be more abstract or detail-oriented, like the one at the top of the facing page.

When I was teaching myself, I found that some of the best practice subjects were animals, followed closely by children. They both move extremely fast and don't care about what you're doing, so you get a plethora of chances to practice your technique. Simply follow them around and try to get great shots. It's hard at first, but you'll start to get the hang of it. Darker subjects, like black cats or dogs, are often harder to focus on—especially in low-light situations—so they present an extra challenge for you to practice on. If you don't have a pet or a child, try to babysit or visit a friend for a few hours now and then.

Photographing these subjects will also force you to be on your feet, moving quickly to get in front of them. In an outdoor setting, you'll find that you move a lot farther and a lot faster. This kind of practice will make it more natural for you to move and shoot with little or no setup.

In an outdoor setting, you'll find that you move a lot farther and a lot faster.

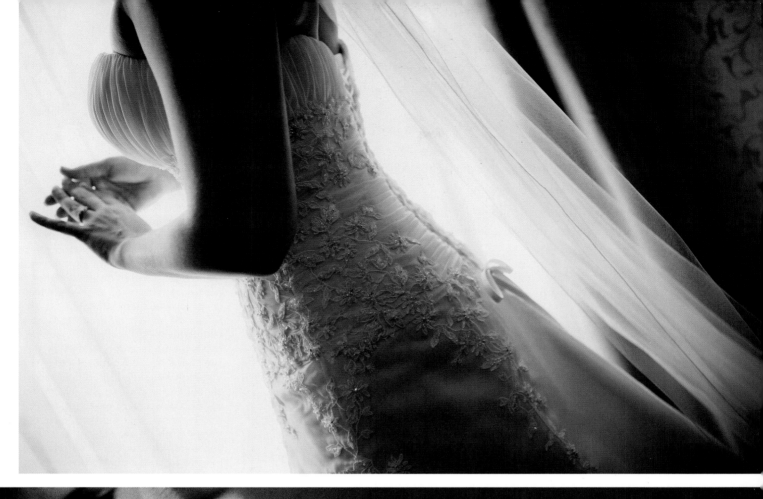

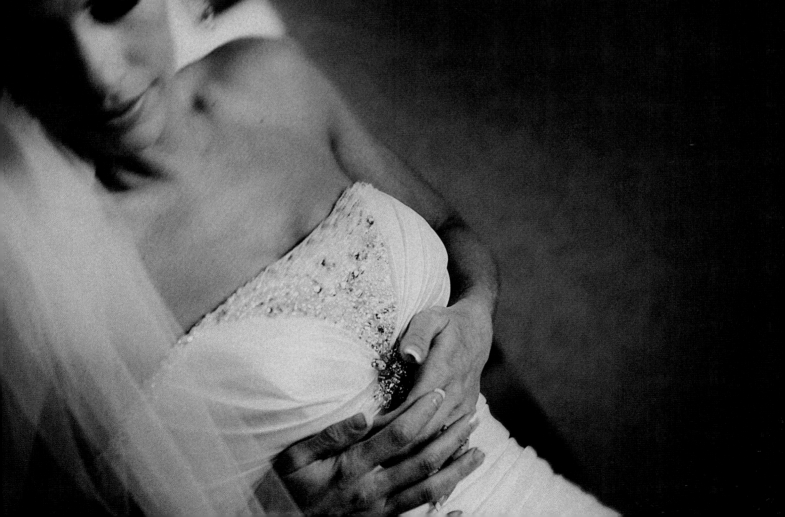

Just moving around with a lot of equipment can be hard at first, but the more you do it, the easier it will be. You can't be too fast, so practice often.

FINDING THE SHOT

How do you select one moment over another—especially when they are similar? Whether it's in camera or during the editing process, you will constantly be grappling with this question. You need to be able to discern which shot is strongest, most flattering, and has the most storytelling ability. It has to have a wide appeal to the bride and her audience of friends and family, but it also needs to be creative and unusual enough to make people stop and take notice.

When people are moving and engaging with one another, emotional displays will inevitably happen. One of the problems this creates for photojournalists is the way that they move, which is sometimes far from flattering. For example, when people laugh, they often laugh extremely hard. An image taken at the pinnacle of laughter is a severe, often far too intense portrait of someone who looks almost as if they were in pain. Usually, it's more flattering to take the shot as the laughter rises or as it calms down. Another prime concern is when a subject pulls their chin toward their chest. This often happens during laughter and it creates the very much unwanted double chin. I find that when the subject is talking to someone tall, or if they laugh so hard they throw their head back a little, I can avoid these unflattering angles.

BELOW AND FACING PAGE—Deciding if a shot is desirable is not as simple as you may think. When I first shot these images, it seemed as if nothing was going right. I had to decide whether or not to delete them on the spot. When I later reviewed them, though, I was able to see the more humorous and story-telling qualities. This type of image will make the bride laugh, and every time she shows it, she'll get to tell the story of how it happened. It adds a needed element of humor to the album and will be a powerful reminder of how she was feeling at that moment—and that things rarely go perfectly at weddings. Photographers and brides both need to remember to embrace the beauty of the day, however it may unfold. Sometimes the best stories—and the most memorable images—actually live in the chaos.

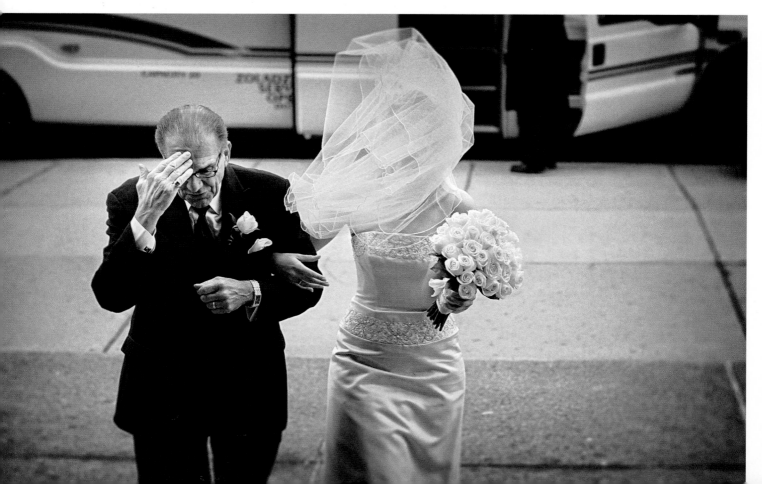

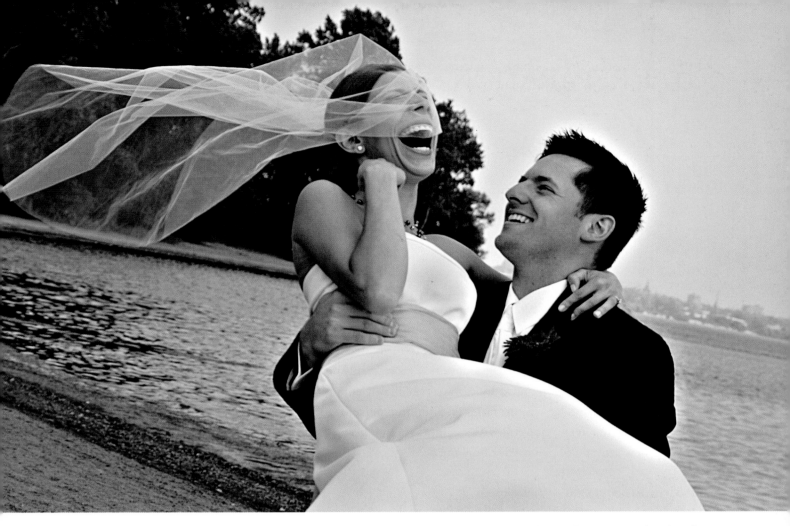

Of course, all people look and act differently, so there are no hard and fast rules. You just have to keep these details in mind as you are deciding when to push the shutter button. Think of it like portraiture. In the studio, you would never shoot someone in an unflattering manner. Make sure to pay attention to those same details in any situation.

Beyond the unflattering details that can be avoided, you need to be able to discern after the fact if a shot is desirable. Because photojournalism happens so rapidly, you will—especially in the beginning stages of your endeavors—end up with a certain percentage of unflattering images. Your job is to be able to sort them out after the fact. For example, imagine you have a series of images of someone telling a joke. Ideally, the funniest part of the joke is when everyone is having the most fun and is most at ease. Sometimes, though, this can be unflattering for the reasons just mentioned. Look at each image as a portrait, then pick the shot that is most flattering and also tells the photojournalistic story.

Pick the shot that is most flattering and also tells the photojournalistic story.

5. PREPARATION

Training yourself to recognize and anticipate the decisive moment is the key factor in learning to shoot in an emotionally charged manner. But to really step up your photojournalism game, as well as hone your intuition more keenly on capturing people in their element, you need to learn to confidently commit yourself to hunting these singular opportunities one hundred percent of the time. When you go out on a photojournalism shoot, you are going to need to adopt a new attitude of preparative thinking.

PREPARATIVE THINKING

Resetting your mind starts with the basics, most of which are things you probably currently practice. Review everything again anyway. It's never a bad idea to recheck your preparatory steps before a shoot. This is, of course, an imperative when shooting once-in-a-life-time events, like weddings, in a photojournalistic style.

Have you experienced one of those irksome moments on a shoot where you turn around and see your subject hugging their loved one—their faces all scrunched up, just aching with happiness because they're so deeply touched—but you miss it? (I'm talking about the irritating moment, not the one that plays out perfectly and lands you with one heck of a shot.) What often happens is that you see the embrace and grab for your camera—but you have to wrestle it from its case, and its strap is knotted around your arm, and you left the lens cap on. Of course, by the time you're finally ready to compose the shot, the interaction is over and the subjects have moved on. The moment is lost. Had your camera been ready to go and in-hand, prefocused with the lens cap safely tucked away, you would have caught the shot. Instead of kicking yourself, you'd be patting yourself on the back.

Instead of kicking yourself, you'd be patting yourself on the back.

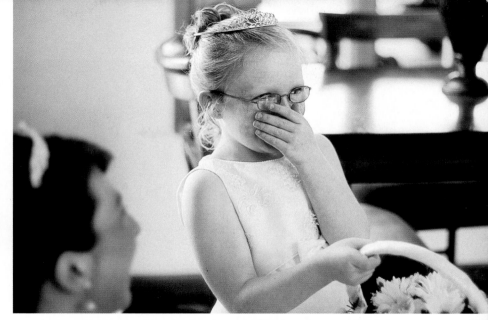

In the past, I would habitually forget that my lens cap was on. The result was missed shots. To avoid this problem, and be ready to capture moments like the one seen here, I decided to put my lens cap in my bag as soon as I started each day. You can only steal these moments if you are ready to go.

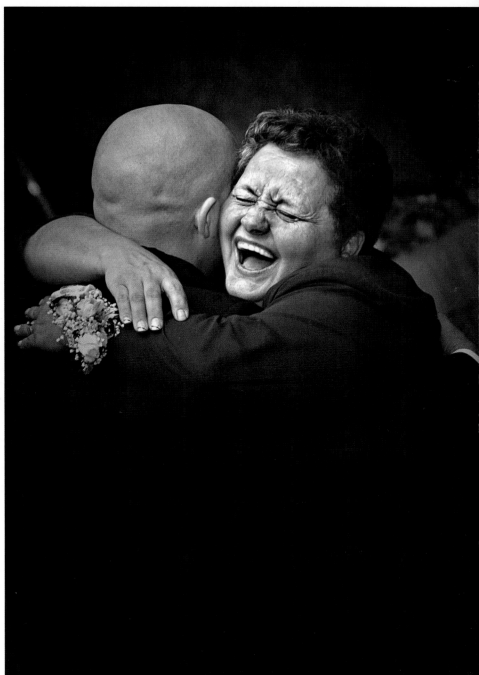

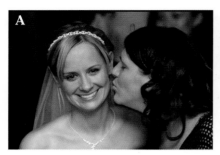 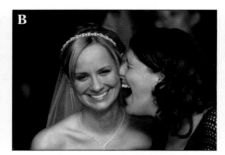 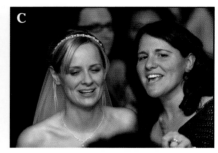

Consider the difference between these three similar shots. Image B is the best because it captures the height of expression. In images A and C, the timing is off by, literally, one second. One second can make all the difference in this style of photography.

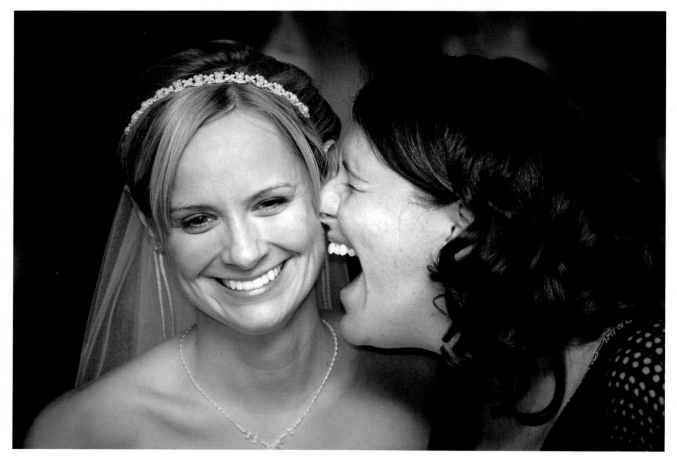

The finished image would look something like this. I chose to make it a monotone in order to isolate the subjects and add impact to the emotion of the bride's friend. In postproduction, I also added a slight vignette and boosted the contrast.

Avoiding this kind of silly mishap is easy: constantly be prepared. Professional athletes don't risk errors by leaving anything to chance; they do everything in their power to eat correctly, hydrate themselves, stretch out, and warm up before the event. Singers warm up extensively before taking the stage; bands do extensive sound checks before even letting the opening act take the stage. Photojournalistic photographers looking to take it to the next level ought to adopt the same attitude: preparation is key.

For instance, check (and recheck) your camera settings. Maybe you changed your aperture during the wedding vows but forgot to reset it when you went outside. Perhaps you turned your flash off for a long exposure earlier and are now preparing to shoot the wedding dance. You and I may scoff and call these rookie mistakes, saying, "Oh, that doesn't happen to me!", but the truth is, something like this happens to all of us on occasion. It is human nature to make mistakes—and it doesn't matter how long you've been shooting; even the seasoned twenty-year vet is human. He will inevitably make an error someday.

In short: given that the odds are already against you, it's a shame to let a simple, preventable error ruin the shot of a lifetime. So check those settings. Stick your lens cap in your pocket. Put your strap around your neck. Everything should be prepared and easily accessible at all times.

Then, go a step further and seek out your subject. Prefocus on them. If they haven't arrived yet, prefocus on a person or object in the general area where you're expecting them to be. This is especially important in a dark environment, as low light can cause autofocus lenses to operate more slowly than in normal conditions. Keep an eye on everyone around you while you're doing this. People will be getting used to you being there and they may start to ignore your presence. You'll be able to snap off a few dramatic candids of other guests while you wait.

If your subject is already engaged in an action or conversation, zoom in and find your desired focal and cropping points. The more accurately you can compose your image in the camera, the less you'll have to be concerned with later. Once your shot is totally composed—your background is perfect, your cropping is good, everything is lined up perfectly—don't jump the gun by shooting immediately. Wait it out. Keep the camera up and ready to go, but be patient.

Don't jump the gun by shooting immediately. Keep the camera up and ready to go, but be patient.

When you see that decisive moment, you'll know it in your gut. When the subject is mid-laugh or just starting to tear up, you'll be so prepared that all you have to do is fire away. As photographers, we tend to look at the technical aspects; the shot looks right, it's in focus, no one is in your way, so you shoot. But consider how different the shot could be just five seconds later.

CROWDS AND DISTRACTION

I find that crowds are simultaneously the most frustrating and the absolute best place to shoot. The good news about crowds is that they allow you to navigate the room almost completely inconspicuously. People are all engaged in conversation and, therefore, oblivious to you. They are also moving and constantly interacting, which creates loaded moments for you to

Use a crowded room to your advantage. Crowds offer a fantastic distraction, as people are engaged in conversation with one another. There are countless little interesting moments and interactions happening. This also gives you ample opportunity to practice your skills. Sometimes I shoot a group situation, other times I like to close in on one person and create a portrait of them in that environment.

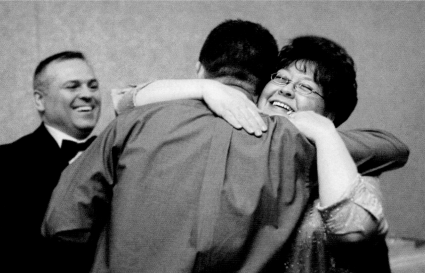

capture. By simultaneously distracting themselves and creating photographic opportunities, they're doing half the job for you!

In a crowd at a wedding, expressive and sentimental moments are sure to occur. I often get bumped into or stepped on, then hear the subject say, "Oh! I didn't see you there." That's exactly what I want. That shows me that I'm achieving true photojournalism, with no posing or participation by the subject. My presence is not changing their behavior.

The bad news? People will walk into your shot constantly. And you'll get stepped on. This makes it important to learn to navigate around people and keep one eye on who's coming toward you.

6. PATIENCE, PATIENCE, PATIENCE

When you walk into a room or into a crowd, a captivating moment isn't going to just fall into your lap. It doesn't work that way. Capturing the perfect moment will take monumental patience on your part. It may happen in the first five minutes, but it can just as easily take fifteen minutes or more. We are waiting for honest expressions from our subjects, and you can never gauge how long it will take for that to happen. All of this is also contingent on your being in the right place at the right time.

LEARNING TO WAIT

Sometimes, people are extremely expressive; right from the start you'll know it's just going to be one of those great wedding shoots. Other times, our subjects are quieter and more reserved. When this is the case, I make it my business to stay near them throughout the day, waiting for them to open up. Often, I only get one or two chances at it—and it may take them until the reception to loosen up. That means I spend seven hours waiting

Wait for a better moment. Don't just photograph a person standing there; wait for them to be engaged in an activity or conversation. It will really enhance the final quality of your work. Attention to these kinds of details is everything.

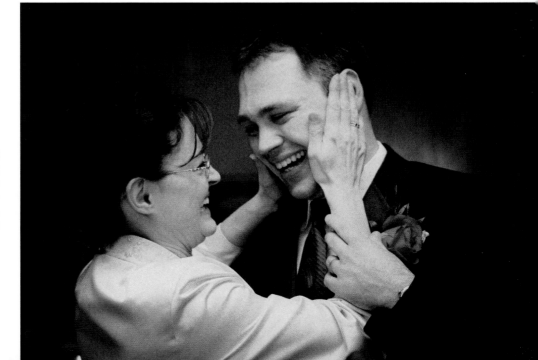

When people are nervous about the big day, they may not smile readily. It may take a little more detective work on your part to catch them at ease. I literally waited all day for the top shot. This dad was a reserved person who didn't smile easily; it took patience and diligence to wait for the moment that would make him laugh. (The rest of the day's photos looked more like the bottom image.) Obviously, there is a great difference between these two photos—and the emotionally charged photo should make the sale. If the bride sees an emotive picture of her father, she will respond positively to it because it reveals far more about who he is than a picture of him sitting idly.

and half a second capturing the fleeting laughter. That's just the way it works. But it makes it more gratifying when I finally get the shot. And when the family sees the image, it's relatively certain that they'll say something like, "I can't believe you got my dad smiling—he never smiles in pictures!"

Don't jump the gun and shoot any old thing. Refrain from simply shooting to record who attended the event—after all, nothing is quite as boring as a portrait of someone with no expression whatsoever. Wait for the right moment. Tap into that reserve of patience. Your arms will get tired as the blood flows away. You'll grow impatient. Sometimes it can take quite a while, but I challenge you to wait until that intensity really shows on your subject's face. You'll be happily surprised by the results. Remind yourself that you're there to record the emotion of the festivities and the personal-

ities of the participants. Most of the time, this means holding the camera steady and waiting—a lot.

PRACTICING PATIENCE AND PREPARATION: THE RECEIVING LINE

A receiving line presents fantastic opportunities for the wedding photojournalist—and is an excellent chance to practice your preparatory skills and patience.

Receiving lines are chaotic; they are full of happy greetings and intense (often overlooked) moments of joy and excitement. As the bride and

If the person isn't particularly expressive, you'll sometimes wait all day to get the shot. Exercise patience.

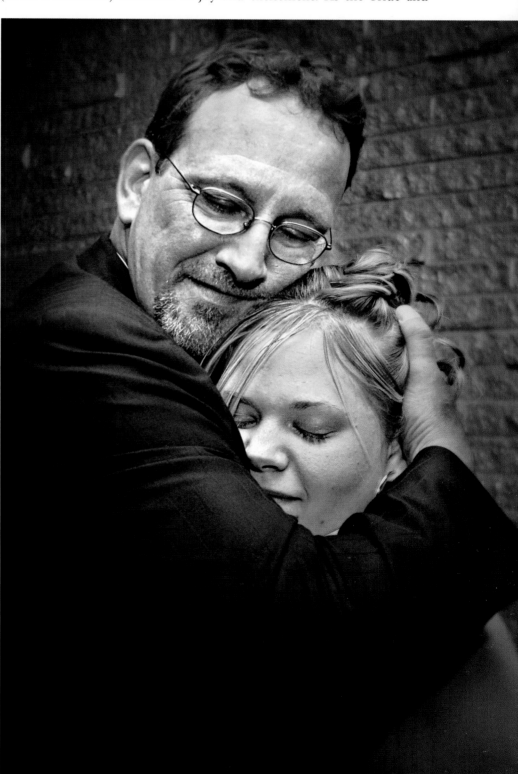

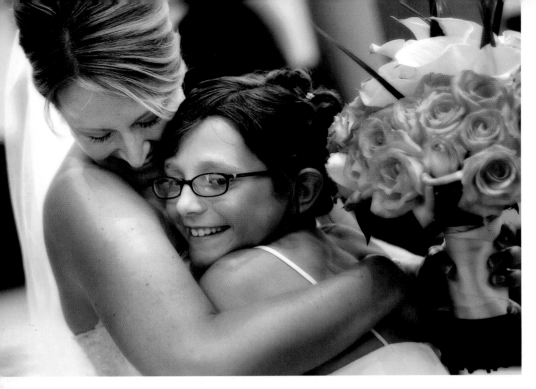

This shot was captured during the receiving line. It is the perfect time to shoot because people are distracted by everything that is going on.

groom greet each person, stay focused in their faces. Grab your zoom lens, pull in on them individually, and wait until that one person who will really excite them comes along in the line. For the sake of argument, let's say that person is the mother of the bride. Her arrival, especially directly following the ceremony, is likely to prompt a few tears. Mom will likely cry a bit, too, so keep your eyes peeled for her expression.

Another skill you can practice while photographing the receiving line is working within a crowd. You'll need to be vigilant about watching the other guests because they won't be mindful of you. They're sure to walk right in front of you and ruin a great shot, so try shooting with your other eye open and monitoring the crowd with your peripheral vision; if you see someone approaching, you'll have a better chance of reacting to them and shifting your position to salvage the shot.

All the while, remain ready. The bride could suddenly grow emotional—and do so without warning. When she sees that old friend from high school, you want to be sure you've closed in on her face and are ready to go. On the other hand, be selective in the moment you choose. You are painting a portrait of her happiness forever, so take it seriously and find that perfect moment, not just the first one that comes along. (*Note:* The same goes for melancholy photographs. If you are shooting a poignant moment, remember that its impact relies on just how much emotion we see in the subject. Don't just create a portrait of someone crying; a subtle, soul-searching expression can actually be far more compelling in its complexity and intrigue. Avoid clichés and look for particularly loaded moments.)

A subtle, soul-searching expression can actually be far more compelling in its complexity.

THE PHOTOJOURNALISTIC PORTRAIT

In advanced photojournalism, it is fundamental that you think of the majority of your shots as candid portraits. They are natural portraits of the person in their environment and should be treated as such. In most cases, you don't want to shoot a group of seven. You are interested in the bride, or her mom, or her sister—or a group of two or three engaged with each other in some way. Close in on those subjects that best tell the story and find/devise an appropriate lighting scenario. When making these choices, be sure to consider what will be most flattering to the subjects. Your customer will respond to that.

It is very important not to dismiss any situation. Emotions are complex and varied, so the most vivid moment could be a melancholy one. Not every great shot is purely joyful. Search for a moving gesture or expression. "Happy shots" aren't the only thing you need.

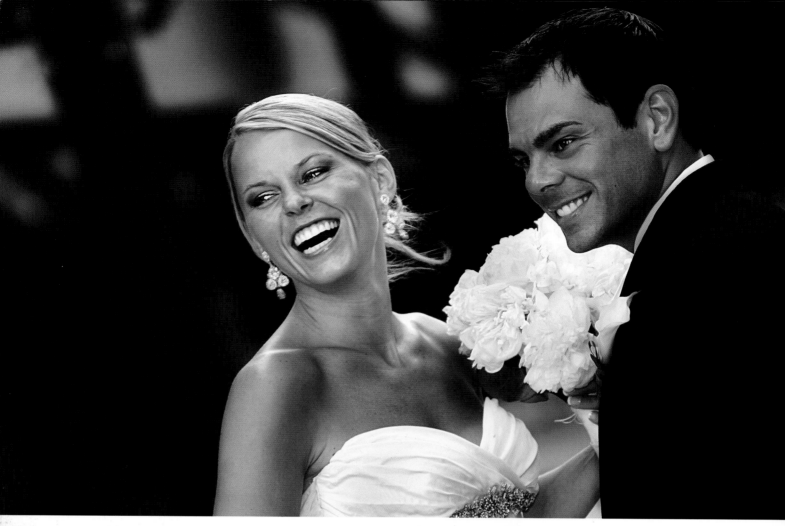

With practice, you will learn to react to the situation as it unfolds. In order to capture these moments, I had virtually no time to think or compose—I just had to capture them instantly. This takes a great deal of practice and patience.

Creating photojournalistic portraits, images that are so flattering and so well designed that they almost look posed, requires you to identify moments so effortlessly that you have time to carefully compose, crop, and edit in-camera before the decisive moment has passed. That will take tremendous patience, but it gets easier with experience. The better the image is when it's captured, the more of a "wow" factor your final portrait will have.

Keep your depth of field relatively shallow and try to rid the frame of any extraneous details. This can often be the toughest part, since you have no

Think of each of your photojournalistic images as a portrait of the person in their environment.

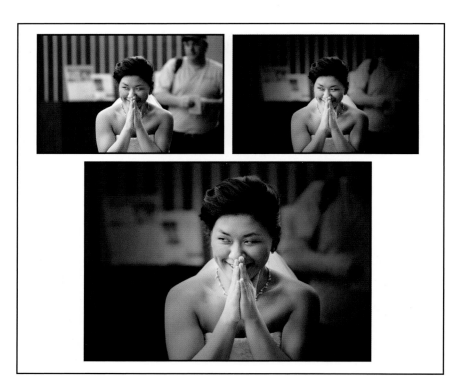

Backgrounds can be particularly inconvenient in this style of shooting. Do your best to overcome whatever obstacles the background presents. In this instance, I couldn't control the man in the lobby, nor the fact that the bride stopped and saw her friend right in front of him. Additionally, the lines on the wall seemed distracting, but I had no choice—I had to react to the scene as it was. When shooting, I used a limited depth of field. In postproduction, I added a vignette in order to downplay the appearance of the stranger and the lines on the wall. A monotone presentation helped decrease the impact of the colors of his shirt and the brochures that would have drawn your eye away from the bride. We can not control our scenes, so we must work with them as best as we can.

control over the action in front of you. If the bride is standing in front of a bookcase, you're stuck with it. Hopefully, the perfect moment won't occur until she's walked away from the bookcase, but you have to be prepared to deal with the unsightly background. Try a very shallow depth of field. Look for different angles. Keep your mind open to the possibilities and don't disregard any opportunity because of an undesirable background.

STRIKING A BALANCE

When shooting photojournalistically, it is hard to know where the action will occur and whom it will be with. It is even harder to predict if your subject will move out of the frame at a moment's notice. This can make it tempting to merely record the events in front of you—to abandon the rules of good composition in favor of getting *something*. Conversely, if you spend so much time thinking, reasoning, and worrying over whether or not this is the decisive moment, you can miss the entire interaction.

The truth is, things won't always happen perfectly; it *won't* be possible to take every picture with the attention it deserves. So don't despair—just keep shooting. If you have time to compose a flawless image, that's wonderful; if you are simply too far away when the action is happening, shoot it anyway. Image editing after the fact can rectify those errors and salvage the moment. When shooting in the photojournalistic manner, a "shoot first, edit later" philosophy is something we'll need to adopt with a significant number of our images.

7. Looking and Listening

At most weddings, you won't know anyone other than bride. That means you won't know the relationships and drama associated with each guest. This can make it hard to distinguish key players amidst a crowd of hundreds. This is an especially important point to remember: it's not enough to concentrate on taking great photojournalistic portraits, it is also important to remember who you are eventually selling these portraits to. You could create an absolutely award-winning portrait, but if the subject is the groom's ex-girlfriend, it won't make you any money. The bride won't even want the proof. What couples do want are excellent informal portraits of their closest friends and family—images that they can treasure over time. Listening and observing body language can key you in to who those people are (for more on this, see chapter 7).

VERBAL INDICATORS

Eavesdropping, though socially taboo, is usually a pretty good idea in these situations. People aren't going to stop their conversation to clue you in, so pay attention. Note the conversations around you—especially those with humorous stories; these are likely to incite great expressions. If you hear key phrases like, "I haven't seen you in such a long time!" or "I can't tell you how proud of you I am right now," highly charged emotions are likely to follow. If you hear the bride's mother say to the bride, "If your father were here, he would be so proud!" and her voice has a slight falter of emotion, find the bride. She's likely to follow that meaningful phrase with a hug or a few tears. And if the bride is tearing up, you know that Mom won't be able to help herself. Basically, as soon as you hear, "Your father would be so proud," you have an idea of where the conversation is heading and you know what reaction is likely to follow. There's no down time when you're shooting people photojournalistically!

If the bride is tearing up, you know that Mom won't be able to help herself.

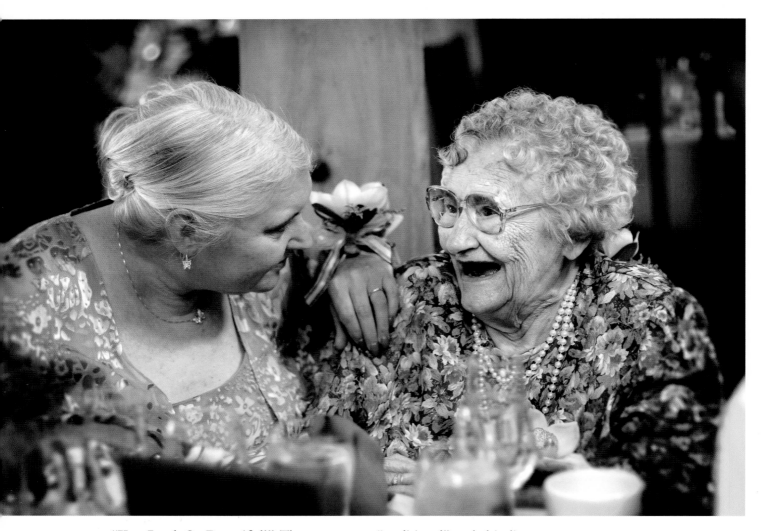

"You Look So Beautiful!" There are some "traditional" verbal indicators to be on the lookout for—expected behaviors that are controlled by societal constraints. In polite Western society, for instance, when people see the bride, they are rather expected to say something like, "You look so beautiful!" The compliments a bride will receive on her wedding day can be overwhelming and exciting. Be ready to capture how she reacts to that. Whenever you hear a complimentary phrase, get ready.

"I'm So Glad You Made It!" This phrase has two implications for the bride or groom: the person they're saying it to is of high importance to them and/or is an out-of-town guest that they have not seen in a long time. Either way, it's a good indication that this is a key player you should keep your eye on throughout the rest of the day.

"That Means So Much To Me!" If you hear this phrase, it's a tip-off that a compliment has just been given. Everyone appreciates a flattering remark, so there will be some kind of positive reaction to this nicety. That means there will also be a great opportunity for a photojournalistic por-

Verbal indicators can often tip you off to where a conversation is headed and give you an indication of an opportunity for a shot.

trait. Compliments to the bride on any aspect of the wedding will reinforce to her the success of the day. It very important to the bride that the day goes well, so you will see the relief and pleasure on her face following that sort of compliment. It is also a common prompt for the hugging to begin—and where there's action, there's the opportunity for further emotional displays.

"Oh My God!" This phrase is so universal that you know everyone will use it—and use it for a huge variety of reasons. It could refer to a guest or parent's reaction to how beautiful the bride looks. It could suggest nervousness and excitement. This phrase is less of a sure thing, but it occurs with such frequency that it provides you with a plethora of opportunities to key in on a subject for a portrait.

Listening to what's going on around you can be the most effective way to discern when something will happen. When you hear the punch line of a joke approaching, get ready to shoot.

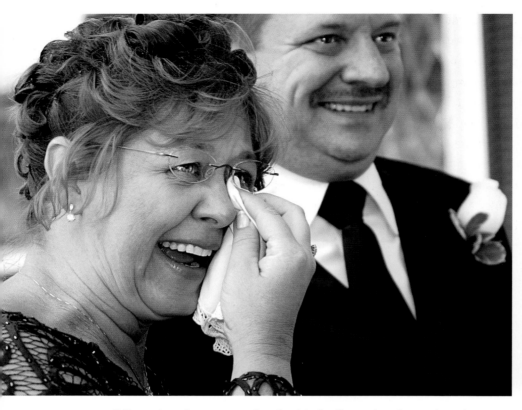

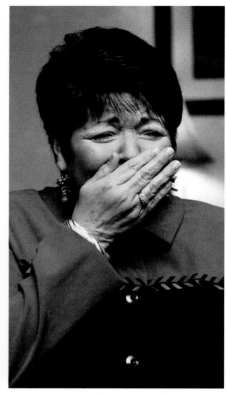

Often, the phrase precedes the kind of emotional reaction that causes other people to get involved. For example, during the morning preparations, let's say the bride is opening a gift that her husband-to-be has sent as a surprise. She opens the small, carefully wrapped box and says in a low voice (or a high-pitched squeal), "Oh, my God!" This suggests the bride is shocked and overwhelmed, giving you your first photo opportunity: the bride's reaction. Additionally, you know that all of the other bridesmaids are immediately going to crowd around to get a look at the gift. The air will be filled with excitement—everyone will be laughing, smiling, and talking, which means more great emotionally charged moments for you to capture.

If you've followed the advice in chapters 3, 4, and 5, you will already have your camera ready to go. When you hear the "Oh my God," all you'll need to do is zoom in on the bride first, then zoom out to include the two people nearest to the bride, and finally pull back to show the rest of the girls and see whose reaction stands out to you. Be aware of the entire group at all times and look for their crucial reactions. Seek out movement and reactions laced with emotion.

The aforementioned phrases are usually good indicators that an emotionally charged moment is about to occur. Learning to predict when these moments are likely to happen is the most significant element in learning to photograph with emotional integrity and lasting impact.

LEFT—Knowing what moment to shoot is the first hurdle. In order to advance your photojournalism, learn which subjects are most important and concentrate on them. This photo shows the pride of both parents, not just one. The bride's parents are important to her, and a shot of the two of them together will have more value to her than an image of either one of them alone. This is one way to infuse your work with the greater sense of value that leads to greater sales. RIGHT—If you hear, "Oh my God," turn around and get ready to shoot. It may just be a memorable moment.

BODY LANGUAGE

How do we tell who is most likely to be excited next? In the chaos of a crowd, whom do you center in on? Verbal indicators may be the most concrete examples for a photographer to key into. However, they are not the sole gauge by which we can estimate where the action may occur next. Body language is another key factor in the anticipation of these moments.

Photographs are a record of human body language. Just as we have been discussing, the moments that we as photojournalists strive so hard to catch are the ones that tell the story all on their own, without using words as description. Reading body language is not an exact science (it is open to varying interpretations), but it is still relatively effective, especially when navigating the uncertain turf of a photojournalistic wedding shoot.

The body language that creates the most impact and communicates most effectively to the viewer is strong and clear. As you survey the crowd, look for clearly distinguishable, recognizable, and familiar gestures. Watch body movement and key into what people are doing. It's almost as if you were watching the television with the sound off; the movements and behaviors of the people would still communicate a good portion of the story to you. Many times, you'll find that you know what they're feeling or thinking without being a part of the conversation.

Consider the body language of this little boy. Even from the back, the slumped posture and the head bent down tells us a great deal about his expression. We can interpret shyness and nervousness from his pose alone.

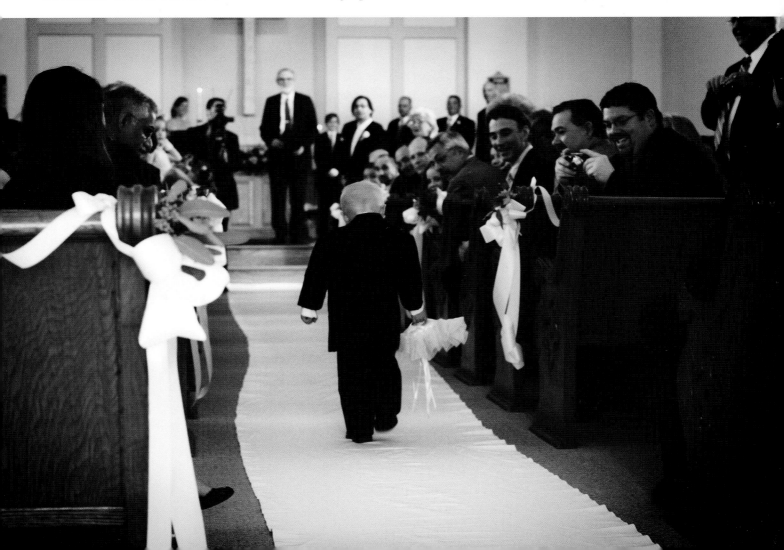

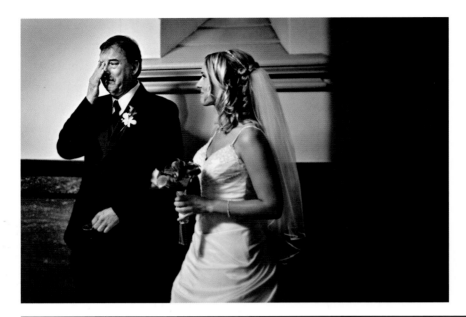

Pay attention to key points in the day that are likely to be emotional for your subjects. The moment before a bride walks down the aisle with her father is a prime example.

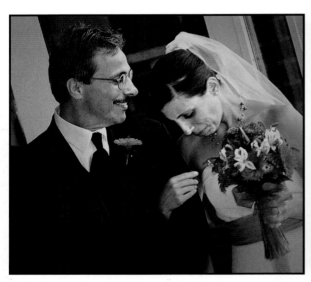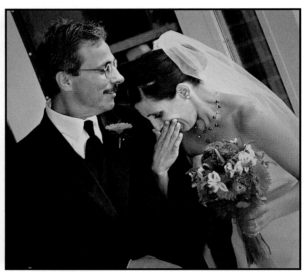

Since body language is automatic and usually spontaneous, it is a tool that you as an outsider can sometimes rely on to reveal that a moment is about to happen. For example, if you see a woman searching through her purse for tissues during or just after the ceremony, it often means she's been moved to tears. If two people are moving toward one another, a hug is probably imminent, especially at a wedding. (Remember, emotions run high at a wedding; hugging and kissing are rather commonplace, so virtually any movement could lead to one.) If two people—like the bride and her father—are simply standing near one another, they are worth keeping an eye on. At some point, it is likely that one of the two of them will put their arm around the other or share a knowing glance.

Watch for clear displays of emotion. Even if you catch one out of the corner of your eye and are unprepared for it, remember that emotions are contagious. People tend to see what others around them are feeling and respond in kind. If a woman starts crying, it is likely that her sister or a friend standing next to her will too.

TRADITIONS

Both verbal cues and body language can help you predict when emotional displays may occur. Beyond that, you can ask yourself which times of the

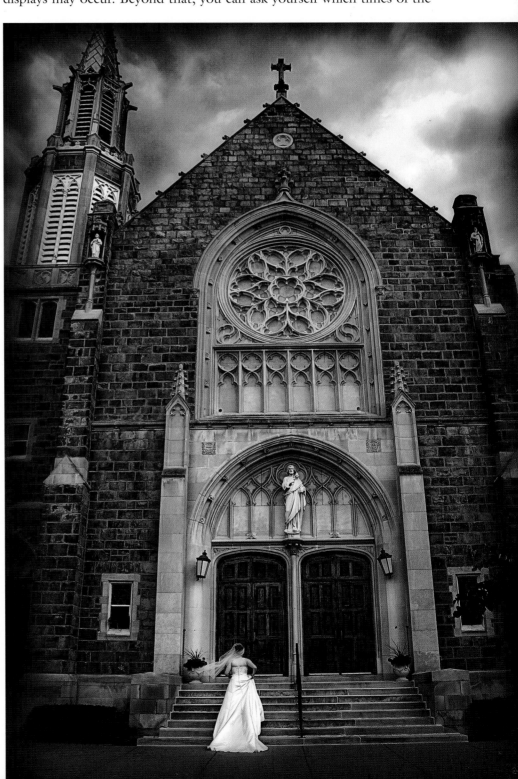

Sometimes, the emotion is in the scene itself and not the person's face. This image was also taken just before the bridal procession, but it has a different perspective. It shows emotion through mood and a feeling of anticipation.

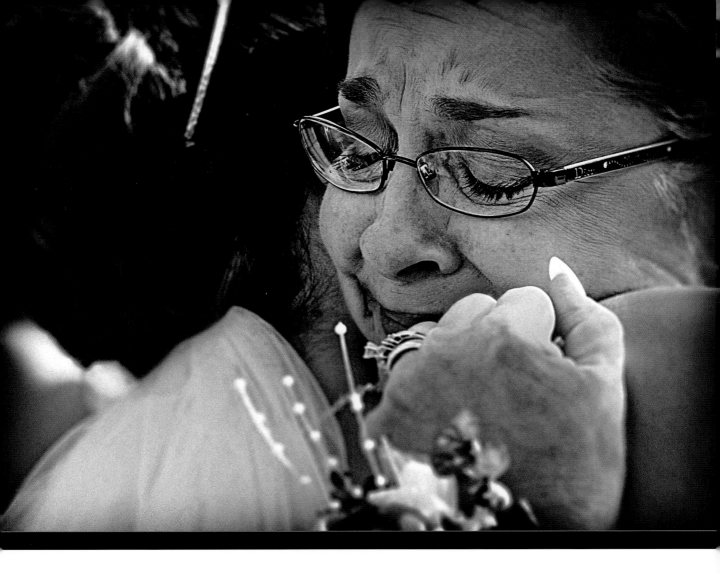

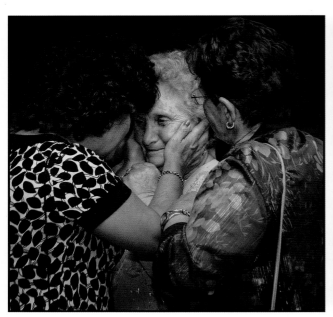

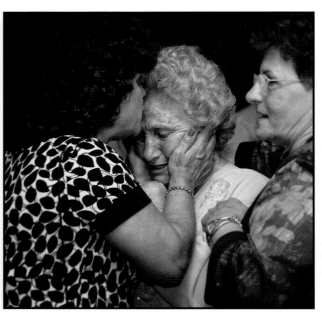

day are the most moving during a typical wedding. You can then use these patterns of tradition to help you discern the "where" and "when."

A good example occurs during the moments leading up to the procession. This is a time when most brides and their fathers are more emotional and demonstrative than usual. It is the pinnacle of their excitement and the climax of the wedding in many ways. Most people are rather nervous about public speaking in any capacity, and the bride is about to stand up in front of everyone she knows and recite her vows. It is daunting and exhilarating for the bride and bittersweet for her father. This combination of emotions peaks in those few minutes before they walk down the aisle—meaning that you will, in all likelihood, get some emotional shots. Not everyone reacts in the same way, however, so you must continue to be vigilant and look for unexpected opportunities.

This combination of emotions peaks in those few minutes before they walk down the aisle . . .

SUBJECT BEHAVIOR

In addition to studying body language, you should learn to observe how individuals are interacting with one another. Throughout the wedding day, start paying careful attention people's mannerisms and movements. Often, you'll find that the bride does something repeatedly when she is happy or when she is touched. You may find out that the mother of the bride gets the giggles before telling a story. After a little while, you will have memorized the best angles for each of them to be photographed—and you'll be able to shoot that way if you keep this information in the back of your mind.

FACING PAGE—You can use people's behavior throughout the day to decide which people are likely to interact with one another. If you discover their relationships—in these instances, groups of friends or a parent—then you'll be close at hand if it looks like something might happen between them.

8. Covering Your Bases

*I*t's important to cover the wedding one hundred percent. The final product we are designing must be powerful—both emotionally and visually. How do you make absolutely sure that you've done both of these things? First, you cover all of your bases by being aware every minute. You should always be seeking out those special moments—as well as finding ways to prod them into action. You can further enhance the look of the day by devoting your attention to romantic details.

GENUINE MOMENTS AND NATURAL SETUPS

Straight photojournalism consists of genuine moments that occur with no interference whatsoever from the photographer. But what if you have been waiting patiently and (frustratingly) found that the shots you've been getting weren't what you expected? Sometimes, a good photographer has to know when to give their subjects a little nudge. After all, not every person will react the way you expect, and not every reaction is as photogenic as the next. Sometimes, things just aren't clicking—but you can't go home empty-handed. So what can we do to speed up the process and help save the day? I find that capturing a mix of genuine moments and natural setups is an intelligent way to cover your bases. No matter what, you've made sure to come home with dynamite work.

Sometimes, things just aren't clicking—but you can't go home empty-handed.

The two biggest dilemmas in photojournalism are lighting and backgrounds. They are almost never conducive to the romanticized moment you are trying to create. Yet, you can't very well jump in there and remove an ugly painting or ask the groom to move over without destroying the spontaneity of the moment completely.

Natural setups solve this problem by positioning the subjects in a setting that preserves photographic integrity. Once the subjects are in place, how-

ever, the moments are allowed to unfold naturally. They are just as unstructured and unencumbered as any other moments during the day. Some may argue that these types of shots are not true photojournalistic moments, but, as a wedding photographer, you are under a certain amount of pressure to deliver. You cannot simply say, "The moments didn't present themselves," and go home. In order to ensure images you and your clients can be proud of, sometimes you need to provide an avenue for wedding-day magic to happen.

Take the bride and groom to a spot you've chosen ahead of time. Make sure the lighting is controlled and acceptable. Check that you have enough room to back off and still get the angle you have in mind, and inspect the background to make sure it is free of distraction. Once the bride and groom are in place, say something inspirational or relaxing to them before leaving them alone. I like to say something to the effect of, "I want you to take five or ten minutes to yourselves here. Reflect on the day so far. Share your feelings. Talk to one another. No one can hear you. The bridal party and I will be way over there." Then, break out the longest lens you have and disappear.

The actions they take during this time are inspired by their feelings, not by their photographer.

They will enjoy the few moments they have alone that day and be able to make their own intimate moments happen. You'll just be the surveillance. Sometimes, you'll find that the couple doesn't even talk. They communicate everything with a look or a gesture. What this means for the photographer is that the perfect moment is playing out like a movie in front of you. All you have to do is wait patiently for the moments that best convey their emotions.

I maintain that this is still photojournalism, because the emotions are as unencumbered by my input as in any other shot. The bride and the groom may have been moved to a less distracting environment, but the actions they take during this time are inspired by their feelings, not by their photographer. The truth of how they feel about one anther is pure; if the groom tells the bride how beautiful she looks and she cries—you are not making that happen. What they choose to do during this time to express their feelings to one another is pure, unposed, and spontaneous. You are simply present to capture it.

By only controlling the background and placement of the subjects, you are not interfering in any way with whatever actions follow. You did not place their hands or tell them where to look. Do not give them physical instruction. Do not interfere at all with the reactions of the subjects. Just wait and watch. Photojournalism is by definition untouched and messy and full of storytelling qualities. You'll find that these photos are all of those things—plus a great background.

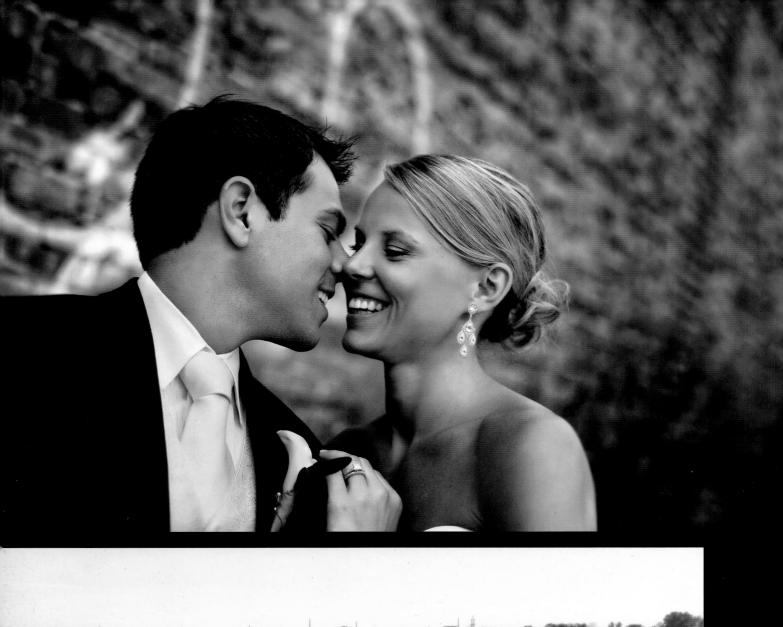
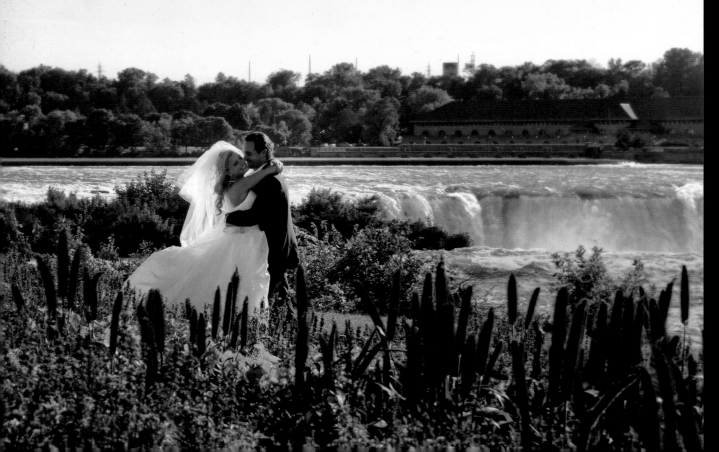

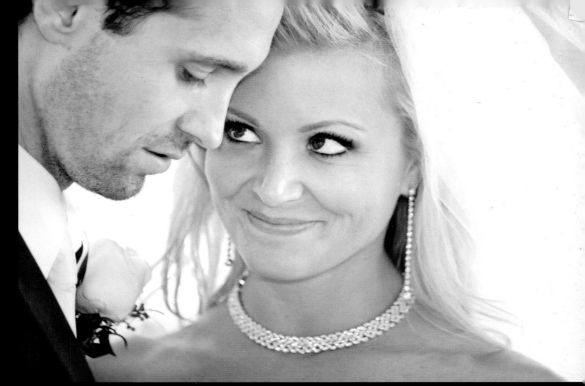

Natural setups can add a great deal of depth to your final product and give you back some control over the day. Set your bride and groom in a desirable location and grab a zoom lens. Let them know this is their time to be together for a few minutes and that they should just enjoy each other's company. Back up far enough that you're out of ear shot and observe what happens. Some people will do more physical things—the groom might pick up the bride—whereas others will register emotion more subtly in their expressions and have an intimate conversation.

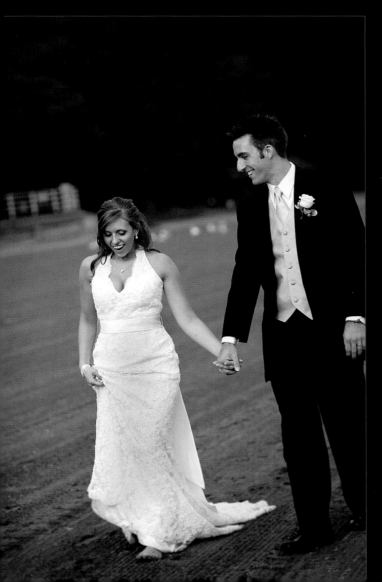

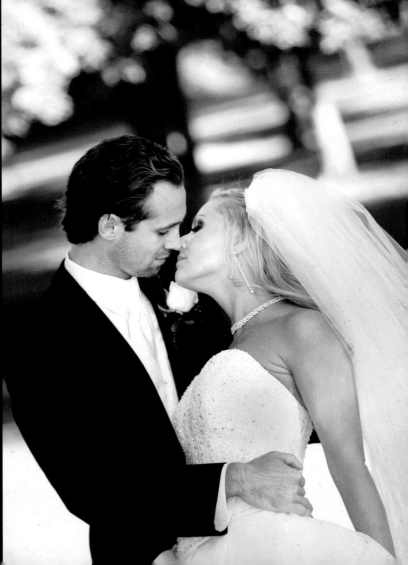

As you're creating these setup images, bear in mind that all of the photojournalism techniques discussed throughout this book remain just as important. Even though you've secured the placement of your subjects, you are not to take control. Often, the bridal party will shout something humorous causing the bride and groom to laugh, or the wind will suddenly blow, or the groom will step on the train. As soon as any one of these things happens, all of your planning will be thrown out the window. You're back to anticipating and reacting what they may do. Be patient. Find that elusive moment.

When it comes to my final album presentation, these setup images are extremely valuable. I know that, along with the candid photojournalism that might have wacky backgrounds or distracting elements, there will also be some clean, well-composed images that are free from distractions. I know the album will be well rounded and professional, while still maintaining the emotionally photojournalistic style I set out to create. The setup moments are completely genuine—all I did was take control of the environment in which the couple shared those moments.

THE BRIDE GETTING READY

If the bride is comfortable having you with her while she gets ready, it will result in memorable images that are sure to become a treasured part of the album. If you are a woman, you will have a much better shot at getting yourself into the preparatory room at this time. If not, though, take heart!

Bridal preparation can be a full of chaos and laughter—and it often takes a group effort from the most significant women in the bride's life, which is an element of support that the bride will want to remember.

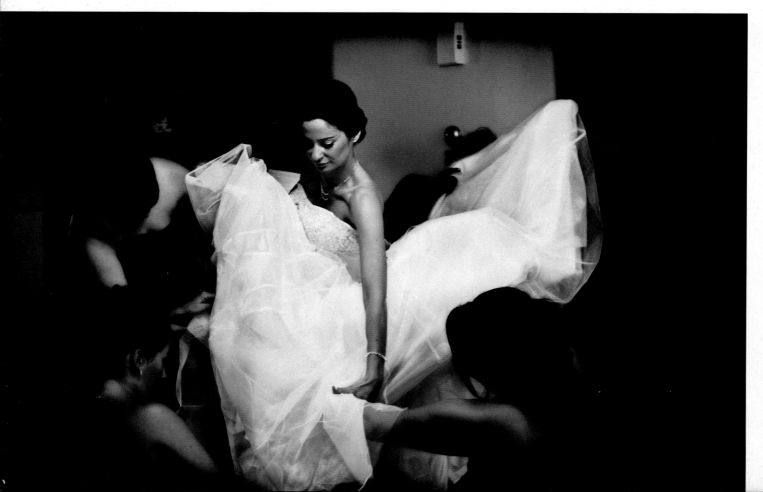

ABOVE—On this day, the bride was sitting on the floor, having her makeup applied. In order to get this shot, I sat down on the floor next to her and chatted with her. She thought I was merely being conversational, and she was busy with her makeup so she didn't notice what I was doing. I used the makeup they had strewn on the floor to my advantage by shooting her natural reaction to what was happening—in the reflection of the mirror. It put a twist on a typical "bride putting on makeup" shot. I was already close, and she was distracted, so I was able to quietly move the compact so that the mirror faced her and I could get my shot whenever her friend did something funny that made her laugh. I usually keep my distance and keep quiet, but I make exceptions for these early shots of the day. RIGHT—In order to personalize a typical "getting ready" shot, I decided on an extreme close-up. I overheard the bridesmaids and the bride's mother remarking on how stunning the bride's eyelashes were. By showcasing them as a part of her preparations, this photo reminded her of their compliments and of how good she felt. Pictures that contain moments like these can be an emotional trigger for the client, which can mean increased sales.

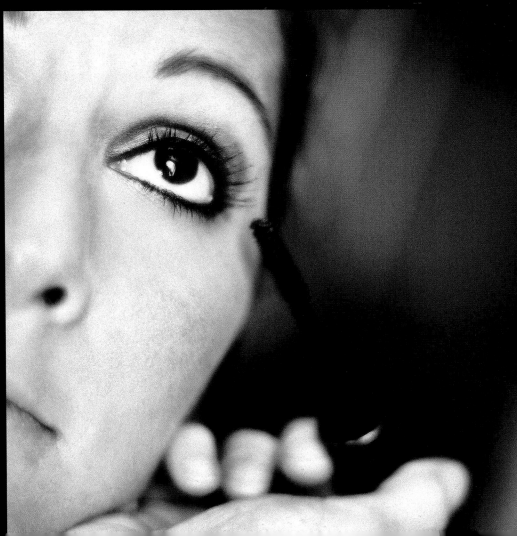

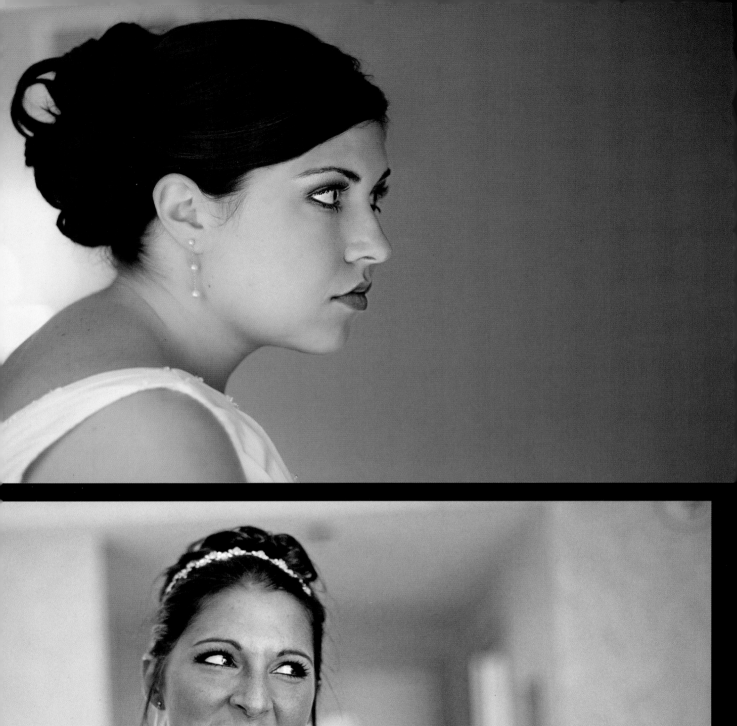
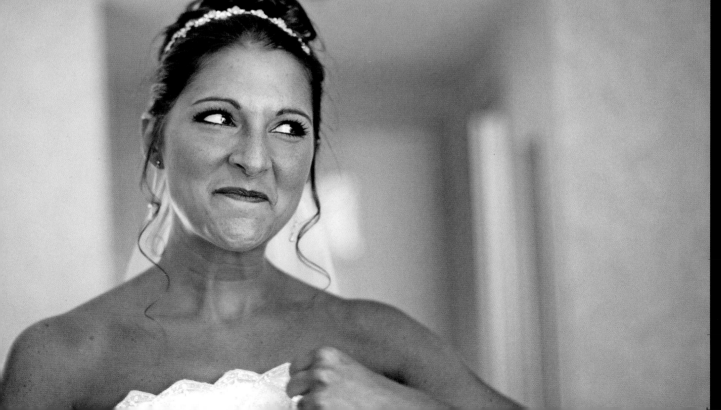

The first time a bride checks out her final appearance in the mirror or emerges to show her friends can be a great expression of the anticipation she's feeling.

You can still get these shots once she emerges. You are not missing too much in the dressing room, since you are absolutely not, under any circumstances, there to take pictures of her undressed or stepping into the gown! This is not the most flattering or memorable moment—and it can make her uncomfortable.

What you are looking for are split-second moments of realization. This is the time when it finally hits her: she'll be married in a matter of hours. The first moments in the bridal gown are also quite emotional for most women. This will last for a while after she first gets dressed, so even if you aren't initially with her in the dressing area, she'll still be glowing when you meet her. The first time she looks in the mirror could also work quite well. Just be attentive and follow her movement as soon as you're allowed.

Since we want to avoid mere recordkeeping shots, you can try closing in on her face and watching for a revealing expression. Also, watch the way her newly styled hair moves in the light. Capture the details of her dress all the way around. Pay attention to what her hands are doing. Is she absent-mindedly fidgeting with her dress or her engagement ring? Is she nervously feeling for jewelry and any missed item? These are just a few of the places you can start to find interesting moments and details.

THE DETAILS

In the photojournalistic style of shooting, detail shots help to create a full and well-rounded product, enhancing the romanticism and the overall look you are creating for the day. Whenever you have a spare moment, get in the

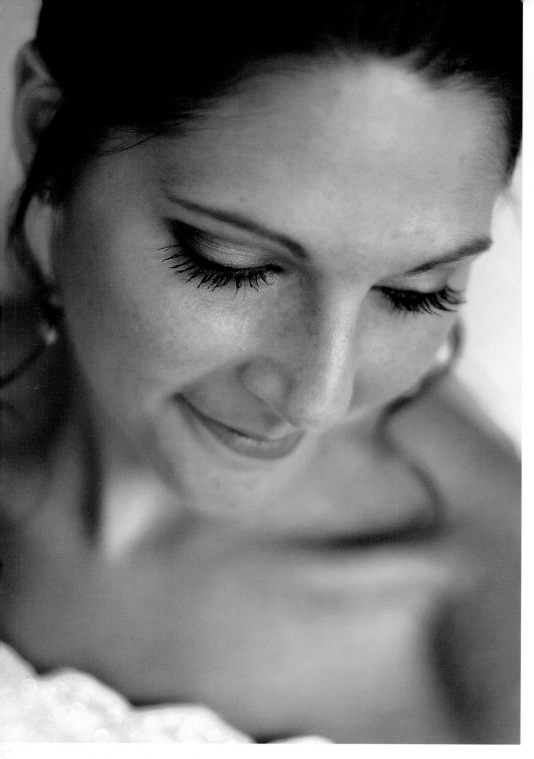

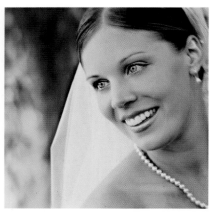

When you arrive, make note of angles and lighting that are flattering. When the bride moves around, you can use that to your advantage and showcase how perfect her hair and makeup were. This is something you need to do at the start of the day.

habit of filling it by creating artistic close-ups of all the details the bride worked on so tirelessly; all of the decisions she's made regarding the wedding are important to her. If you aren't sure of what those details may be, pay attention to what the bride and her family are saying about things.

The Bride's House. Don't know where to begin? The bride's personal effects are a great place to start. The dress is, of course, the pinnacle of interest on the wedding day, but that's just the first of many details. For ex-

ample, I often hear brides and bridesmaids remarking about their shoes or matching pedicures. They are happy to show off their feet for a picture, and they get a kick out of it. Make it your goal to incorporate these things in an elegant way. Each of these details will later bring a smile to her face.

Brides often add more personal flair by including family heirlooms that are rich in personal history. Be sure to inquire about hairpins, handkerchiefs, or any other items that look as if they might be significant. They often have great stories attached to them which will give you further insight into the family you are getting to know. That will help you to later identify

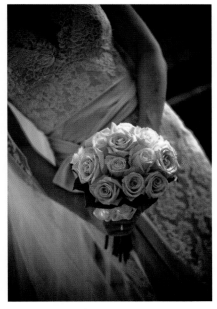

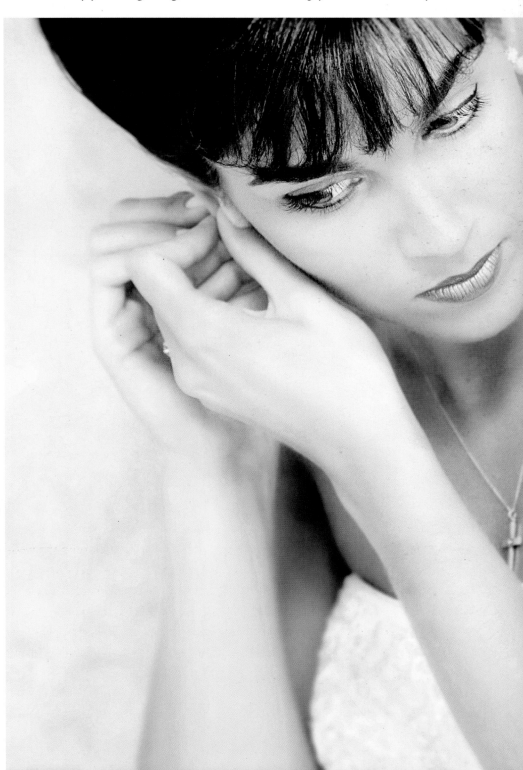

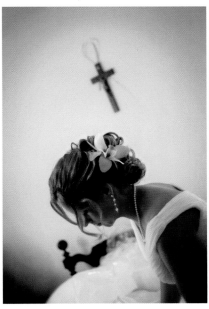

Pay attention to the thoroughness and care a bride will exhibit on the big day. Make artistic and flattering choices that highlight all of her efforts.

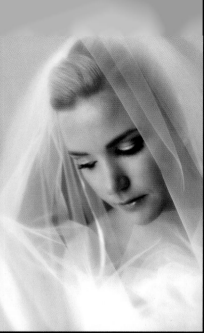

Start your wedding coverage by photographing all of the bridal details. Perishables, like flowers, are especially important to photograph early in the day before browning and wilting might occur. If the bride cries, her makeup won't look as good later—so this is a great time for your close-up portraits. You can also use detail shots to display the bride's personality (below).

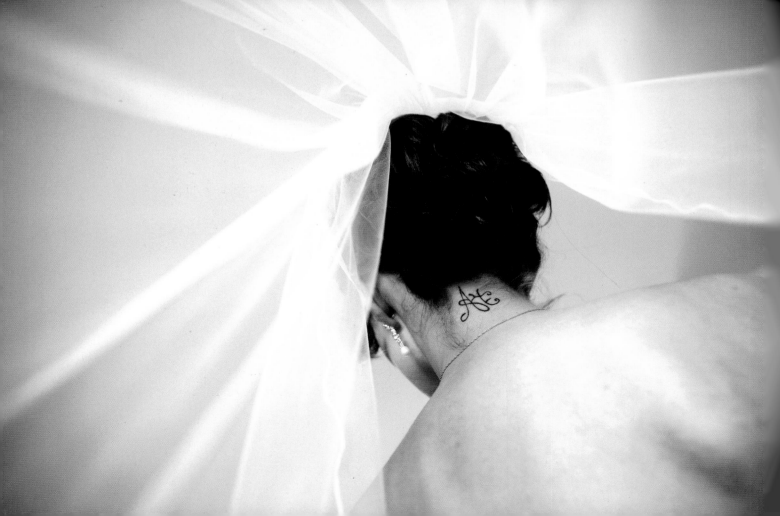

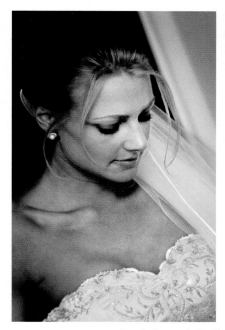

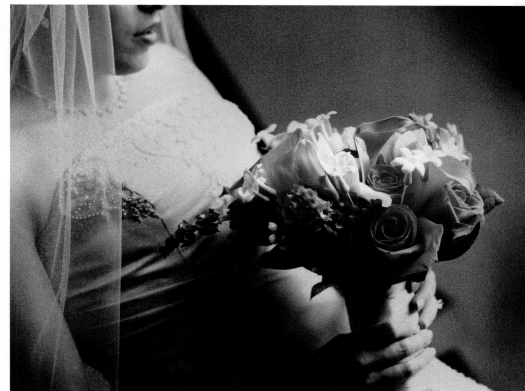

TOP LEFT AND RIGHT—Don't be satisfied with a record shot of the details. Find an artistic edge that you can make your own when photographing a rather traditional detail (top right). Record bridal details like hair and makeup on the fly without her noticing. I did not pose this shot and the bride had no idea it was taken. I was able to accentuate the details of her beauty while she was distracted by other things (top left). **RIGHT**—Do not have a preconceived list of the details that are important. The most touching aspects of the day tend to be small things you notice along the way.

close relationships between those people and give you a good starting place for candids.

Additionally, the flowers are an essential addition to any wedding, and they are chosen with a great deal of care. Be certain to shoot them early in the day to avoid any wilting or browning. No one will appreciate a close-up of a dying rose.

Remember: you are selling to the bride, and your goal is to touch her emotions. These are all items that she's personally spent time selecting, and

ABOVE, RIGHT, AND FACING PAGE—Take note of all of the important details throughout the day. The bride will appreciate your thoroughness. In order to keep your work fresh, experiment with innovative cropping or fresh angles on a subject you often shoot. The framed and matted images to the right give you an idea of how you can display several detail images as a unit, resulting in one final piece that demands more respect, looks more professional, and can tie together several parts of the day. Alternately, you can design a wall-size enlargement from a detail that would have seemed inconsequential on its own. Offering your customers a specialized product like this gives them a way to purchase and display unique work as a whole.

you'll be able to arouse a lot of sentiment in her by adding a few marvelous shots.

The Ceremony. At the ceremony, any personalized touches are of importance. If there is a homemade chuppah in a Jewish ceremony or a mandapa in an Indian one, it will hold great meaning for the bride and groom as well as for their families. In a Christian ceremony, decorations may be placed on the altar or pews. There will likely be a unity candle, symbolic of the two families being joined in unison. These details are all highly personal and have been paid the greatest attention by the bride, the groom, and their families. They are strong emotional triggers for people and hold a great deal of symbolism that adds to the story you are trying to capture. The family will be thankful for your interest and attention to detail.

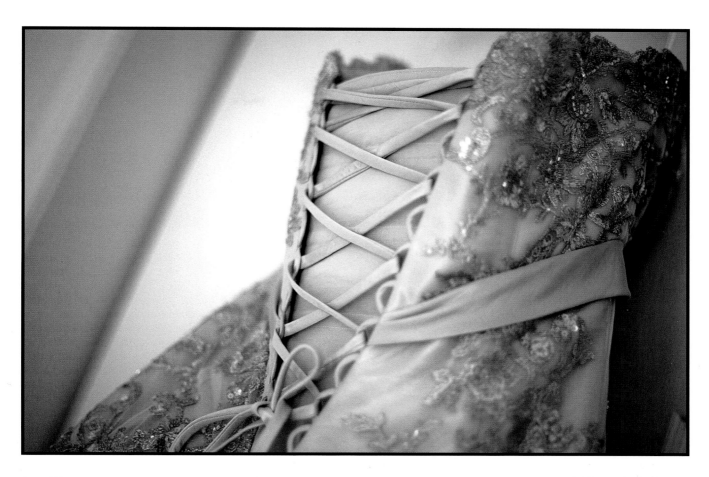
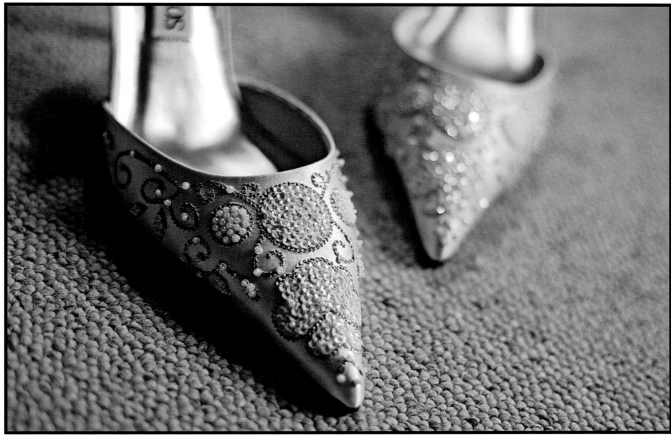

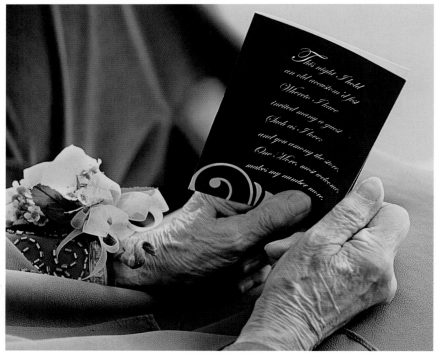

TOP LEFT—A child's perspective on the bride's entrance and the ceremony is very telling in its own way. TOP RIGHT—Ceremony coverage can be very repetitive. Try to incorporate unusual details in order to add to the uniqueness of your bride's big day. To enhance the photojournalistic challenge, find ways throughout the day to incorporate detail shots. You will likely need a zoom lens to do this. LEFT—Look for details throughout the ceremony that can add an unusual storytelling element to your coverage, without being traditional.

The Reception. The cake, candles, place cards, and specialty favors can enhance the look of the day—and images of them add a feeling of completion in your final work, showing that you went above and beyond for your client. A photo of a carefully chosen or meaningful object can evoke just as strong a response from your clients as a portrait. They are important touches that add another level of thoroughness and detail to your final product.

The People. If you really delve into this concept fully, you'll begin to see "details" within the contact of two people. For instance, consider a close-up image of the groom touching the bride's arm or running his hand across her back. Such gestures portray love and tell the story of two people in a different light. These types of shots are photojournalistic in nature and concerned with people, but without being traditionally framed portraits.

Begin to see these moments as artistic expressions of love. They are stylized, intimate, and unique.

If you'd like more of a challenge, try to shoot the details of the day in a photojournalistic style. Don't set anything up. Look for the moments where the items are displayed perfectly and shoot them in action. It provides more depth to the photos when the items are in use. The bride won't even know you took the pictures, so she'll be that much more delighted to find them. Of course, it's important during a wedding to always be covering all of your bases, so you may want to record the details in the traditional way throughout the day as well, just in case you don't get the photojournalistic shots as planned.

Available Objects. Available objects can add a lot of interest to your photos and enhance the impact of the overall album. They help break the cycle of monotony that can often trap wedding photography. They also add a unique feeling that the bride and groom will enjoy a great deal.

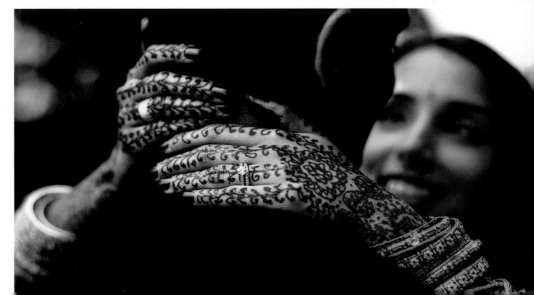

ABOVE—I wanted to add some focus to the maid of honor's toast, but didn't want to take a picture of her notes or her reading them. In order to spice things up, I was able to focus on the notes and get a great bridal reaction in the background. TOP RIGHT—Do not stick to a controlled definition of a detail shot. Here, I decided to combine a more basic detail (the cake) with a background of a more intimate detail (the groom taking the bride's hand). BOTTOM RIGHT—Detail shots will extend beyond the flowers and the cake. Traditional accents are important and well thought out choices for the bride. As the day progresses, find interesting angles and shoot them without anyone knowing.

Found objects can be literally anything, provided they make sense in your story. There is no way to know when or where you will find them. You have to keep your eyes open and don't immediately discount anything without thinking it through. If you see flowers growing in the grass, wait by them until you get a clean shot or use them to enhance your traditional posed shots for the day. If people leave behind a program or a box of tissues, that can tell a great story by itself—even without your subject in it.

A cutout in a bench can create a frame for a picture. A fence can help frame a portrait, or a doorway could add depth to your shot. Doorways in particular seem to add a feeling of voyeurism, which really enhances what your photojournalism is about. The possibilities are endless in this area and can add a spark of creativity, so don't discount anything.

In this image, a heart-shaped cutout in a white bench became a frame for the bride. I used the time when the other photographer was taking traditional portraits of her to find the right angle and snap off this shot.

Any found object can add a totally different perspective to your work. Look for anything that catches your eye. In this case, I found a lone patch of wild daisies growing in the grass. The other photographer was working with the bride and groom in a traditional manner, which allotted me enough time to get down on the ground and compose a totally different kind of shot.

9. IMPORTANT CHARACTERS

*J*ust as we pick apart the inanimate details of the wedding and the important roles they play, we need to learn to identify and assign values to each of the people at the wedding. Who should we keep an eye on? How many frames do we spend on each subject?

PARENTS

The parents are an easy place to start honing these skills. At most weddings, it is a good bet that the parents will play a big role in the day and mean a great deal to the bride and groom. This is not a guarantee, however. The first thing you need to do is a little probing. Find out if all of the parents are in attendance and identify them. Pay attention to how they interact with the bride. You will often encounter estranged relationships or some that are simply just not that close. On the opposite end of the spectrum, some relationships are very close. Know what you are dealing with in order to know whom to compose portraits of throughout the day.

For example, if the bride makes her mother the maid of honor, it's a good bet that they enjoy a very close personal relationship and you will benefit by taking a lot of frames of the mother interacting and having a good time. You will also know to compose a lot of shots with the mother and daughter together, sharing moments. Alternately, if the bride does not ask her father to walk her down the aisle, or perhaps you overhear her talking about how much he upsets or annoys her, then you know the relationship does not a warrant massive amount of photojournalistic portraits.

The actions they take during this time are inspired by their feelings, not by their photographer.

If the parents are divorced, do not spend time composing a shot of the two of them together. On the other hand, if they have enjoyed a thirty-year marriage, make sure to try to get a shot of the two of them laughing together. It is a moment that both they and the bride will value—

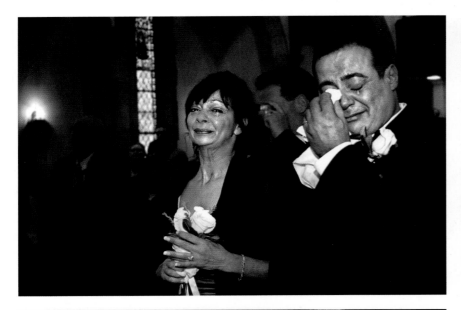

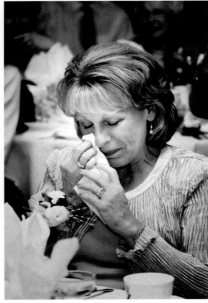

The parental perspective on the day is important to the bride as well as to the parents. It adds an even more touching element to your coverage, and it can mean double sales if they both want copies.

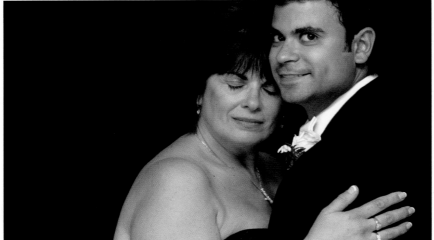

and composing a shot of the two of them makes it worth more than a shot of just one of them. Its perceived value is higher. No one ever wants to leave someone out. I often hear, "Well, I can't get a shot of my dad if I don't get one of my mom." This emphasizes how important it is to cover the whole family at an event. Everyone who is important and close to your client ought to be equally represented.

It is important to spend your shots wisely and not waste valuable time overdoing one person in particular, especially if you can gain insight into their history and you find that it may not be a person the bride is willing to purchase an 8x10 of after the fact. The main concept is emotional triggers in the viewer. Make sure you never forget who you are selling to and the reason why he or she might purchase the photo you are creating. It is not an exact science in any way, but giving it some thought may just help boost your sales and your positive feedback.

Everyone who is important and close to your client ought to be equally represented.

CHILDREN

A flower girl or ring bearer can add immeasurable amounts of emotional joy to a wedding album. They bring an innocence and spectacular cuteness to your pictures. They incite the "Aww!" response from viewers and add another perspective to the wedding. The children included in the wedding party were selected by the bride and groom for a reason, so you want to afford enough time to get good shots of each of them. In formals, they are often the hardest to pose and (when tired) can be the hardest to elicit a smile from. Shooting them in a photojournalistic manner is an ideal way to transcend this boundary. Follow them around and use a zoom lens where possible. Make sure not to discount any activity.

Flower girls often make very cute subjects and are a "sure thing" in wedding photojournalism. It's a safe bet that you'll get at least a couple shots because they are less interested in you than the adults are.

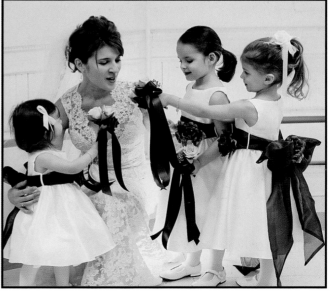

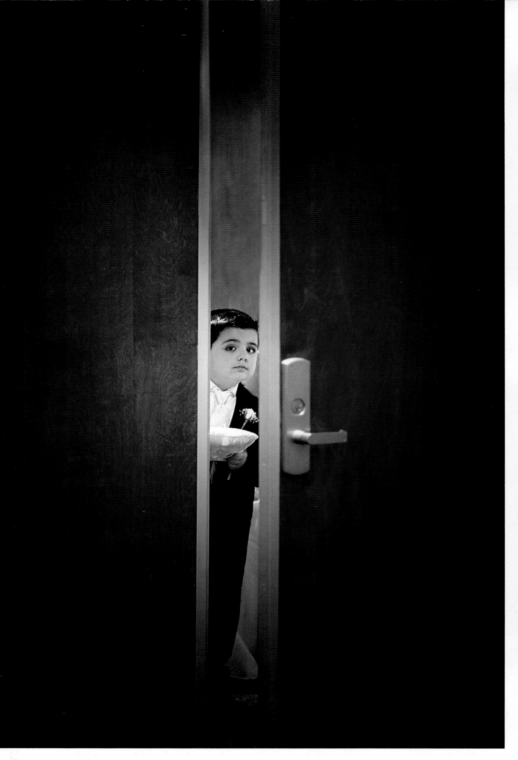

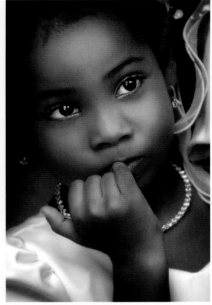

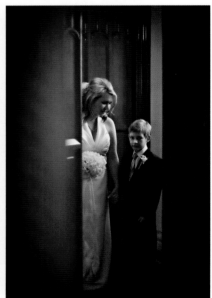

Kids can be nervous, too. Prior to the procession, kids are often particularly expressive, making for pictures that project excitement and anticipation.

Furthermore, the way that they interact with guests can add real impact to your album. A photo of them watching the bride and groom or a shot of the mother of the bride playing with them tells a great story and adds a great deal of resonance to the final collection of photos. Because angle is much lower than everyone else's, including kids can have the added benefit of prompting you to shoot a traditional shot from a far more innovative angle. Keep an eye on children at all times.

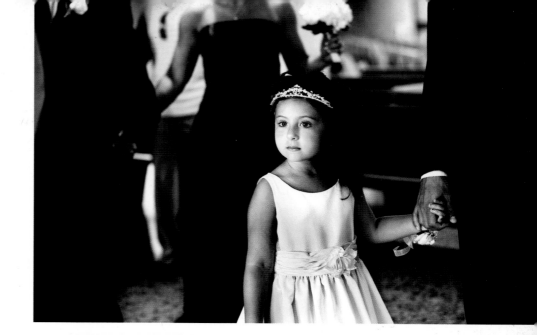

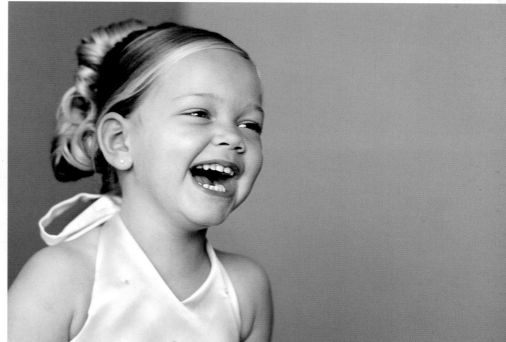

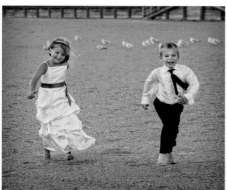

Incorporating great photojournalistic portraits of the children involved in the day will boost your sales and add a distinctive cuteness factor.

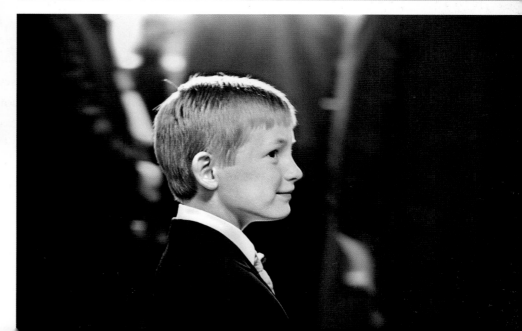

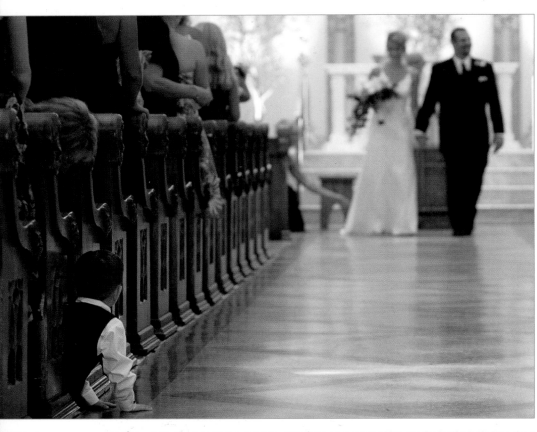

LEFT—Try to see things from the children's point of view for a unique vantage point on the day. BELOW—The father-daughter dance is likely to produce emotional and photo-journalistic shots. They are distracted by the dance and are usually very emotional.

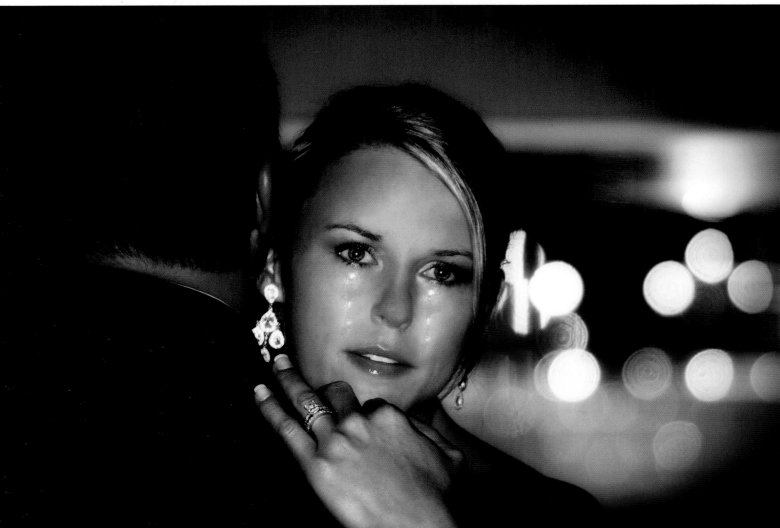

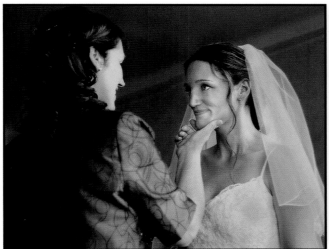 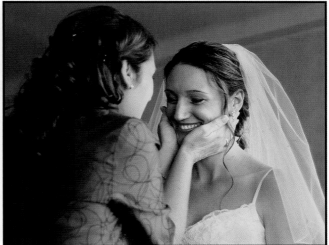

ABOVE—Make sure to pay particular attention to interaction between parents and children or grandparents for great shots. RIGHT—I knew who the grandparents were, so I kept my eye on them. To get this shot, I remembered one of the most important rules: keep your distance. This photo was taken from at least six feet away. I stayed back—unobtrusive, silent, and out of the way. In postproduction, I was able to crop in, allowing me to create the image I wanted without having to interrupt the moment or have them notice me.

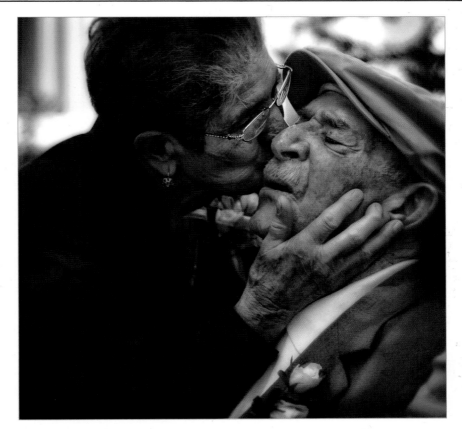

THE EXTENDED FAMILY

We know that parents and children play an important role. It is important to pay attention to them in photojournalism. Beyond that, grandparents, godparents, and aunts and uncles are all important subjects. The most influential people in it must be identified so you know who to shoot. It is a virtual guarantee that if you are photographing these people, your bride will be satisfied that everyone has been represented.

10. EQUIPMENT

*N*o matter what equipment you use, you can employ the techniques of advanced photojournalism in your work to enhance your products and prompt the bride's desire to purchase them. As I've noted several times throughout this book, equipment doesn't make the image—you do. As you hone your skills, you'll determine what tools are best suited to your shooting style and the kinds of images you want to create.

THE DIGITAL ADVANTAGE

Film can add a special element of nostalgia through its coloring, grain, and monotone qualities, but digital photography does give the photographer a number of profound advantages. In addition to adding the effects that you liked when shooting film to any image you've shot digitally, you can enhance color, crop as needed, and make any other changes needed to optimize the images for your clients.

Another consideration is the fact that a wedding day is long—often twelve hours or more. That's a lot of candid photography. It can be costly to develop that many rolls of film and reprint them. It can also be time-

In order to capture this image, I stood behind the guest tables and used a 300mm lens. Using a long zoom lens ensures that the expressions you capture will be totally unaffected by your presence.

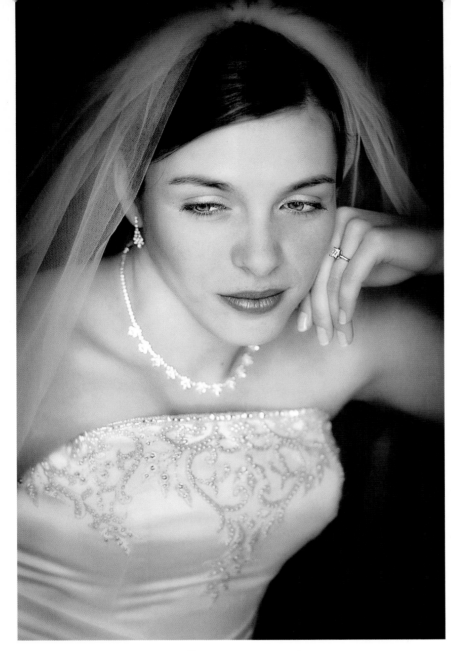

Since this was a digital capture, I was able to apply my own special effects in postproduction, creating a feel to match the bride's expression.

consuming (and irritating) to sort through dozens of similar-looking negatives for each series of shots of people interacting.

There are a lot of near-misses and not-quite-perfect shots that occur in this type of photography (if your objective is to give the bride three-hundred high-quality images, you may shoot upwards of a thousand frames to get the perfect moments). It is just the nature of the craft—and when we are trying to push the boundaries of tradition, we will need to keep working at it continually . . . meaning even more exposures. Lots more.

Another huge advantage is the ease of discarding unwanted photos. You can shoot more rapidly and not worry about cost or space issues. You can also shoot any moment that may look promising, then check back later to see if you captured it well. If you didn't, it's easy enough to trash it and move on.

If your files are digital, the time you spend in postproduction will inevitably increase, but the control you will have over your images is immense. You will be able to delete extraneous details, crop away dead space, enhance lighting and color—you name it. Special effects in postproduction also allow you to create a one-of-a-kind personal style in your images and better enhance the story being told by each moment.

Most importantly, digital capture allows you to make more mistakes. This is an experience-based craft; you need to try, fail, and try again until you've got your style down pat. It is a trial-and-error system. You may make several versions of an art piece before homing in on the specific look and mood you want.

Photojournalists strive to capture the subject, story, and emotion of the moment. While we should try to address issues of cropping and framing at

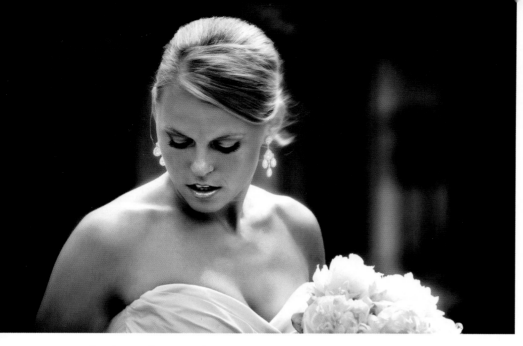

Using natural light and zoom lenses allows you to capture these moments in the most flattering way, without the subject's interest being piqued.

the time of capture (just to minimize postproduction time), we also know that these can be easily handled after the fact when shooting digitally. Knowing this can make it easier to concentrate on capturing exactly the right moment. In short, image-editing software can help alleviate your own anxiety and keep you focused on your subjects' emotions.

LENSES AND SUBJECT AWARENESS

Ensuring that your subjects remain unaware of you is vital to natural photojournalism, so you somehow need to afford yourself some space—distance between you and your subjects that grants you privacy. If you are less than three feet away, you are in their personal space. Your subject is not only likely to be aware of you, but looking at you and wondering what you're doing.

A zoom lens can afford privacy most effectively. The farther away you can get, the less the subject is impacted by your presence. It also keeps you from being constantly on the move; you can stand in one spot and survey the whole crowd, selectively choosing which scenes are most exciting. A zoom lens gives you a whole lot of options while moving your feet minimally.

A zoom lens gives you a whole lot of options while moving your feet minimally.

NATURAL LIGHT

Shooting natural light is something photographers should learn to do whenever possible. It adds feeling to your images and gives them a softer, more personal quality. It sets the scene, adds drama, and can literally set the subject in a flattering light.

Additionally, it helps preserve your anonymity. Most subjects will notice a flash going off in their peripheral vision. The people you are shooting

will also turn and look, thereby killing the interaction you are trying so hard to capture. If you can shoot with natural light only, they will be less likely to notice you are there. In a noisy room, they won't even hear your shutter so you'll be free to shoot away.

Choosing faster lenses (lenses with wider maximum apertures) will help you when shooting natural light. It's not always possible, but it is something to strive toward.

PUSHING THE ENVELOPE: EXPERIMENTATION

In order to take your photojournalism to the next level, try to incorporate all of these elements as much as possible. Get the best lenses you can, and know when to use each one. Shoot with natural light as much as possible, without sacrificing quality or exposure. Master your camera settings and hardware so that you can make them work for you.

Once you have captured the perfect moment full of impact and intrigue, allow yourself to experiment in any way you'd like. Try messing with your exposure or shooting from an angle you would otherwise find silly. Later, use image-editing software to enhance aspects of the photo that would go unseen or add an overall look that you never thought possible.

Experimentation takes practice and patience, but it can add a quality or mood to your photo that was previously not present or not intense enough. In this photo, I exposed for the bride's skin and blew out the background almost completely. Later, I used Adobe Photoshop to add a cross-processing technique (previously used in film). I also did some manual manipulation of the background lighting in order to get rid of the extraneous details.

Once you get started experimenting, there is no end to the possibilities. You may come up with some real one of-a-kind prints. Just be sure to save the originals so that your client has their choice of photos—in case they don't agree with your choices.

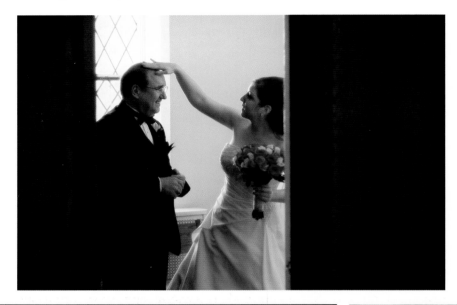

Once you've developed your instinct, you will use the common-sense techniques and thought processes that we have learned in this book to answer the "where" and "when" questions on the wedding day. Instinct will guide you toward capturing moments at the height of emotional resonance.

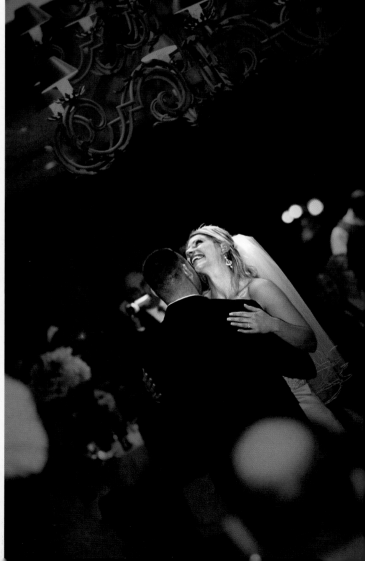

11. POSTPRODUCTION AND ARTISTRY

Careful image editing and a few special effects can increase the value of your work. You want your customers to be in awe of the final products—products that are perfectly refined to reflect the glamorized version of events that they remember. This means that the effects you use should be realistic . . . but in a slightly better way. In most cases, you'll simply want to get rid of extraneous details, enhance colors, and take care that nothing is distracting from your romantic depiction of the day. Aspire to make it perfect and soft at the same time.

MONOTONE IMAGES

It is important to shoot your weddings in color so that the bride has the most possible options. If you shoot in color, you will have the ability to decide if an image should be presented in black & white—and she will have the opportunity to disagree if she likes. This covers all of your bases.

Having said that, a monotone effect often greatly enhances your work because photojournalism is, by nature, all about the subject and the story. Color can enhance that, but it can just as easily serve as a distraction. At

When shooting photojournalistically, you will often find that monotone images are more effective. They strip down the image, forcing the viewer to take in only the great impact of the person's expression and their story.

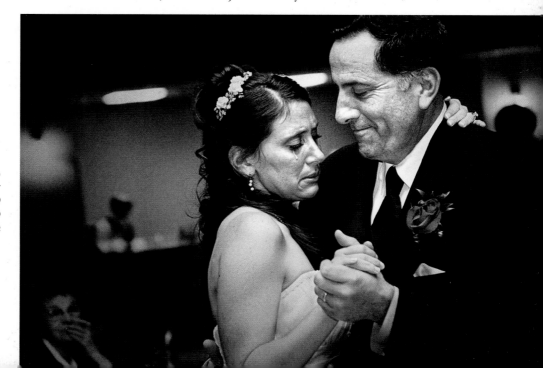

weddings, I find that colors often create distracting backgrounds. For example, many wedding guests wear brightly printed dresses that can create a problem when they appear behind my subject.

By taking the color out of a print, you strip it down to its essential elements. Your brain has no choice but to process subject matter first, which redefines the picture by enhancing the emotion and action. Black & white (or monotone) prints are often simple and extremely full of impact. They also have a nostalgic and classic feeling. Brides frequently describe them as timeless.

LOSING EXTRANEOUS DETAILS

It is important to crop in the camera as often as possible. However, if you are quickly hurrying to capture a moment and you abandon your cropping principles in order to catch it, you can fix it after the fact. Any image-editing software can aid you in this endeavor.

Make sure to crop in the way that best serves the story you are trying to tell. For example, crop out the people in the background having an un-

Sometimes an unusual crop adds an element of interest to your photo. In this case, I chose a long panoramic crop in order to lose the extraneous details (personal effects left on the floor) and include the door frame. I use foreground objects like door frames to add a voyeuristic element.

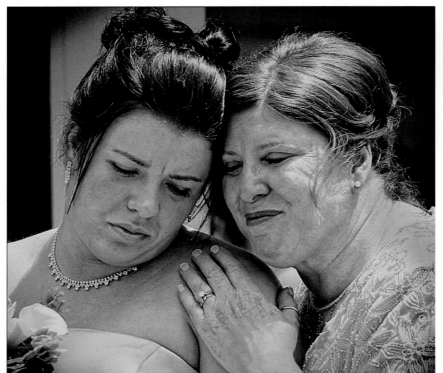

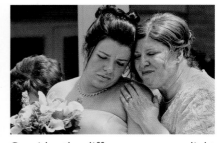

Consider the difference even a slight crop can make. In this image, I was able to eliminate the grandmother, who happened to be walking through the shot. By doing that, our eyes are solely focused on the action between the mother and daughter, with no distracting background elements.

Cropping can often make all of the difference in your final product. In this image, taken while the bride's dress was being laced up, I had several problematic elements to deal with: a distracting picture frame on the wall, the father of the bride standing directly behind her, and half of a bridesmaid's shoulder. By deciding on a vertical crop I was able to eliminate all of these extraneous details.

related conversation, but save the part where the bride and groom are holding hands. It is often all about gestures and expression, so make sure you crop to enhance whichever quality makes the most of your image. Photojournalism is creative and unusual, so you may often find yourself using an untraditional aspect ratio—like a square or a long, narrow panoramic shape—to best enhance what you are trying to present. These types of crops will later add unique style to your framing choices.

Image-editing software can also make life easier by removing unwanted stray hairs, hooks on the wall, or flower petals that have broken off. No matter what process you use to rid yourself of these nuisances, your work will benefit extremely from the time and care you put into it.

SPECIAL EFFECTS

Image editing software can allow you to change your digital photos in order to re-brand them in your own personal style. Allow your "look" to develop. Try to use specific qualities or effects to develop a signature style that you will later be known by. This allows people to identify your work and gives it a unique voice. For example, you can try muting the colors in your prints, or enhancing them more. You could add a vignette, a blue tone, or a sepia tone. There are no set guidelines in this area because the style you develop has to be uniquely your own. It must be original.

Although you will want to add in a few exotic and artistic shots to your final album, you should also be certain that you've given the bride a timeless product. Address the overall mood of the photo. You may want to use warm and vibrant colors to set a pleasing tone, as in these images.

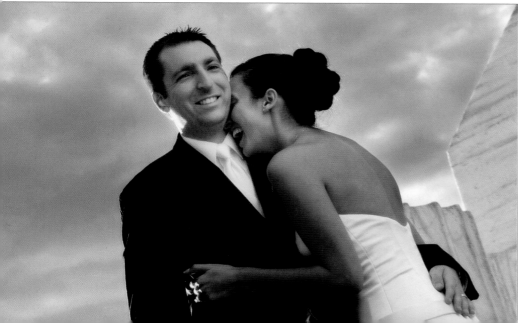

Experimenting with postproduction techniques will lead you down paths you hadn't considered. You will be able to come up with interesting artistic effects to enhance your images. Just start trying things out to see what fits the best. Artistic techniques can reveal themselves in the stylization, cropping, story, or mood of your work.

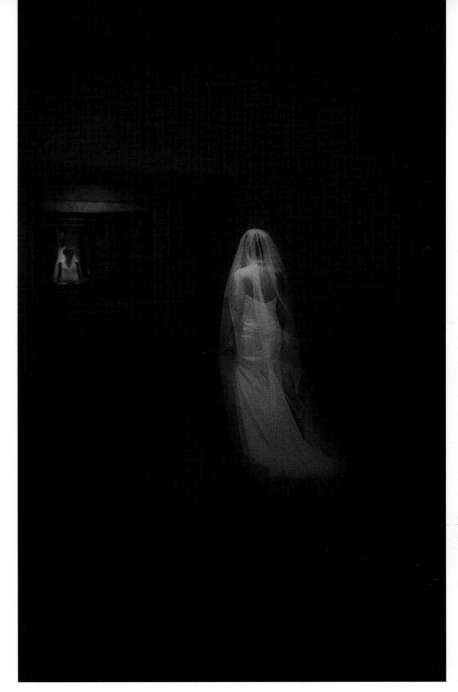

When developing your own personal style of photography, bear in mind that you are working on wedding photos. Most of them will need to have a romantic vibe. You can throw in a few experimental shots at each wedding, but the bulk of your shots must be romantic enough and standard enough to fulfill the bride's expectations. The selected "unusual" pictures then look even more interesting and exciting by comparison.

A FINE-ART APPROACH

If you want your work to transcend the idea of a "candid" shot, you need to treat each print individually as a work of art. There are a variety of ways

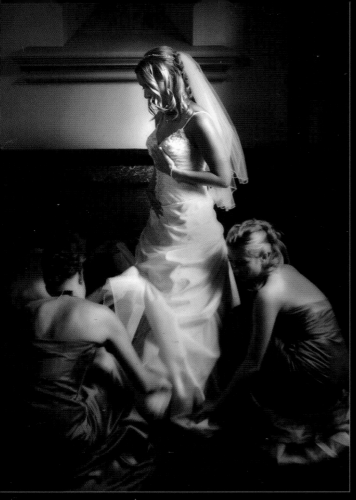

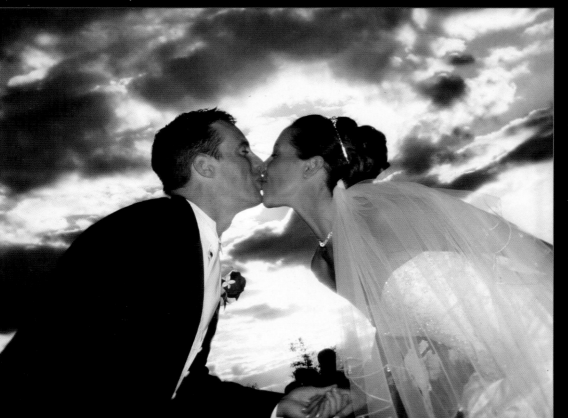

Always establish a strong mood and point of view. If the photograph demands cool coloring and contrast in the details (above right) make sure to attend to that. If the mood strikes you as quiet, give your image the appropriate coloring to make that point (above left). Try to make your work realistic yet romantic. You want the bride to remember things the way they were—but maybe just a bit better (left)!

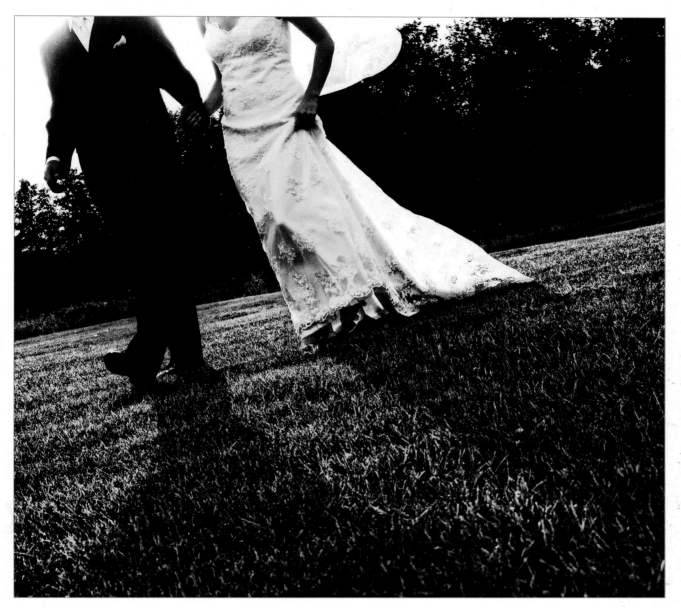

Experiment with your lighting and camera angles on the day of the shoot. Then experiment with your postproduction techniques. Make choices designed to create a piece of art that will demand respect.

to do this, but always bear in mind that the piece needs to be polished and strong with clear meaning. Choose photos that have the specific qualities that you are looking for, then filter them, frame them, or print them in a thoughtful manner.

To complete a piece successfully, train your mind to think creatively and artistically. Don't just frame a piece, finish it. Think outside of the box. Does it warrant being printed on canvas? Should it be printed really large, on a huge board or plaque? Should it be printed very tiny? Does it warrant a gallery mat or a huge white border? The subject matter should guide your answers to all of these questions.

When getting started, the only way to find out what products will work best with your images is to try them. In my experience, it's also the only

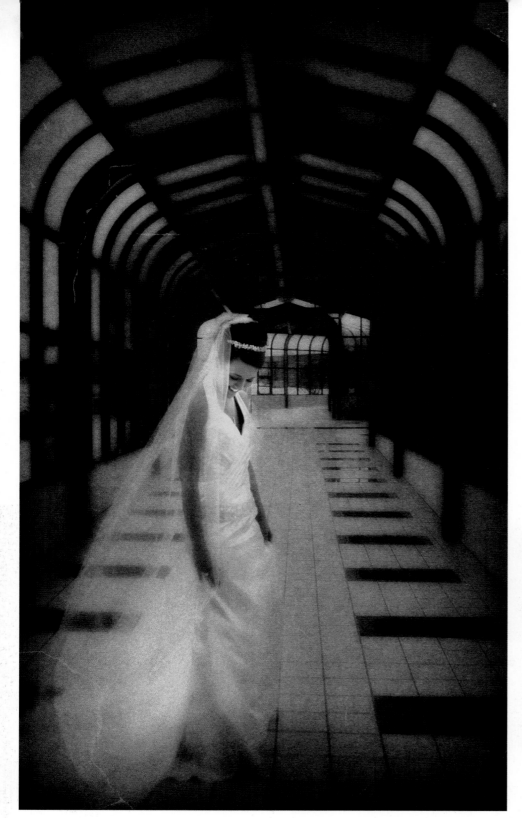

The only way to develop a unique style in your photography is to experiment. Your more artistic images will add a welcome change to the overall proof book that you provide to clients.

Try unique printing services like watercolor or fine-art papers. They produce an extreme matte finish but with texture. When warranted, this type of printing can add depth and intrigue to your work.

way to push your craft further into places you never thought it could go. You will find that you surprise yourself. Allow yourself to explore any option available to you in order to create new moods and effects. However, use discretion! Too many special effects are a bad thing.

The finished image is all about the mood it presents and the feelings it evokes in the viewer. A dark and moody image might require a dark mat and huge, deep frame. Conversely, a ridiculously cute little girl making a funny face might be printed small with a broad white mat to draw you in. If you find yourself with a series of pictures, think about the best way to display them together. Don't forget coloring and treatment when editing. If you are printing for a specific colored frame or mat, you need to make sure that they will complement each other.

Any special effect that you play with can lead you in a new direction. Explore your options and keep an open mind. Get customer feedback to see if you are heading in the right direction.

Advancing beyond traditional photojournalism will require you to think outside of the box. Succeeding will require immense discipline on your part to continually try new things and experiment with new technologies. Don't dismiss something without giving it proper attention first. A by-product of constantly being creative and trying new things—even if you ultimately discard them when they don't work—is that you are constantly training yourself and gaining more and more experience. That is invaluable. Embrace your creative side and don't be shy, even if it feels a bit silly. Continually try something new. If you keep pushing yourself in this way, you won't be dissatisfied with the results of your efforts.

Push yourself to be creative and you'll see your art grow in directions you never considered.

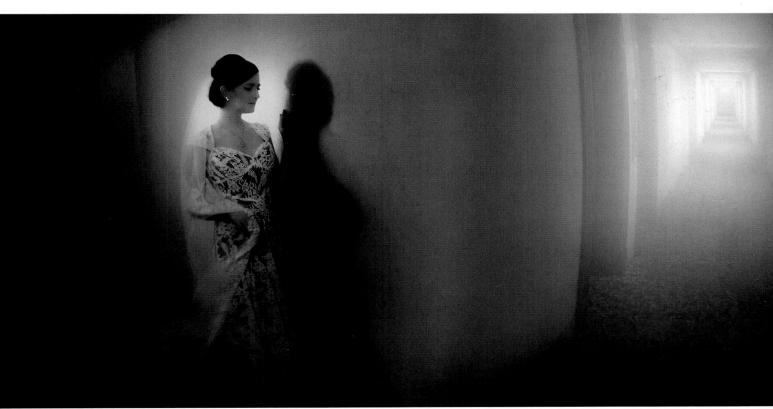

12. Increasing Profitability

Y ou've just learned a whole lot about photojournalism, but your client won't share your level of expertise. As we discussed back at the start of this book (see chapter 1), a certain portion of the photojournalistic sale is dependent on the education of the client. They need to understand the subtle differences between types of photography, methods of achieving the photos, and the services you offer for finished treatments of images. Other important factors include your image pricing and presentation—as well as how you edit your images at the proofing stage.

SELL BEFORE THE SHOOT

The more your clients know about your craft, the better they can appreciate it. It's important that they understand what kinds of photos you will be taking so neither you nor they will be disappointed.

Show them your enthusiasm and your passion for what you do. Explain to them that the creative realm is experimental and you'll never know what might come out, which can create outstanding photography. Get them excited about having you photograph them in this honest and unique way. It is extremely gratifying when your customer believes in your work as much

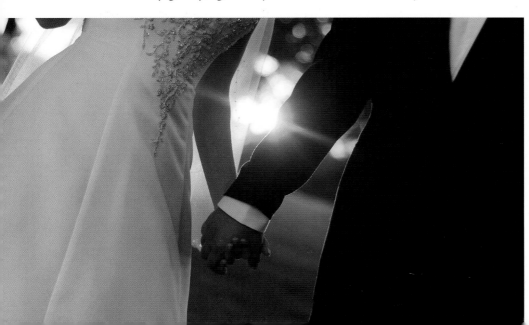

Provide your client with only the best version of the photo. If there is only one version of the image with no similar ones to choose from, the selection process will be that much easier for them and the demand will be that much higher.

Take care in the presentation and editing of proofs. The more effort you put into it, the better your products and sales will be. Photojournalistic images often require a little bit more cropping and editing in postproduction than traditional ones, but your hard work will pay off in extra sales.

Your sales will be based on your customers' responses to your work.

as you do. It makes sales easier, appointments faster, and the overall process more fluid. You will revel in the excitement of a satisfied customer when they get a product that is truly unique.

Most photographers hold a booking appointment where they initially meet the client and give them the pertinent information. This is an invaluable opportunity to both learn about the bride and groom and give them some advice on how to navigate the world of photography. Ask a lot of questions so you know what they are looking to spend and what products they are looking to buy. If you are forcing information on them, they will not thank you for it—and it is unlikely to result in sales.

Once you know about their preferences and tastes, you will better be able to suggest add-ons, such as albums, frames, or photo-based merchandise. You will be able to find the products that best fit what they actually want. After all, clients can't purchase something they don't know exists.

TIMELINESS

Sales are all about making the client feel happy and comfortable. Brides can't wait to see their photos, but they often have a lot of fears and anxieties surrounding their photos, as well. Be sure that you balance offering the best product you can with a timely turnaround. The best time to talk to your bride about offers you have is during her post-wedding bliss. You don't want her attitude toward you to turn sour because you take forever to get her the pictures. Your best sales will result from making the photography a fun part of the wedding planning.

DIGITAL PROOFS

Digital proofs can be a blessing and a curse. The world of digital photography allows us to shoot wildly and without restraint, but that should not mean that we don't edit our results. If you provide your customers with digital copies as proofs, you need to take the same care in editing that you would with a print. Whether they view their proofs on a computer screen or in an album, your sales will be based on your customers' responses to your work. If you give them a lot of untouched, unorganized files that are not color- or exposure-corrected, they are not likely to order much (or have the confidence in you to book future sittings). It is also not likely that they will give you glowing referrals, which can cost you business.

Edit down your photos for impact and identifiable individualization— you want works of art, not just pleasant candids. If you offer your clients ten similar photos, they will not have the same impact that one profound photo would. Let them see one finished, polished version of the photo

you've chosen. Then the photo will be its own piece. It will be a singular, great moment. It will not compete for attention with any similar moments or have any trouble standing out. Also, choose your proofs carefully so that they tell the full story without omitting any parts of the day.

Exercise the same care in digital proof production as you would with prints. Make your work stand out and look like it's worth a lot. Photography sales are all about perceived value; the image must seem worthy of its price. Furthermore, throughout the proofs, your style should be evident and your photojournalism should look the best it can. It is very easy to forget these principals when working with digital proofs.

Advanced wedding photojournalism should yield products that look indisputably like works of art and not sloppy candids. They must have a polished and finished resonance.

ADD-ON SALES

Photojournalism is atypical in that the shots created throughout a wedding day vary a great deal. They are also integrated with each other so well that they need to be handled differently.

Since they tell so many stories, photojournalistic images lend themselves best to a matted series in a frame or in a book. There are a vast number of books available for all different budgets and tastes. You can help the customers pick the right photos to be framed in a series or to fill out a book—and that will help them know where to put which kind of photo.

You should also think about applications beyond framing. Specialty companies and labs can provide you with photo jewelry, ornaments, and gift boxes, or even lit-up frames. You could provide a service with a scrolling digital frame and the files of the pictures of their choosing, or you could put them on a personal necklace to emphasize the uniqueness of the artistic vision you are selling. A stretched canvas, in particular, can go a long way toward making the viewer feel that they are finding your work in a gallery-like setting—and they will be more likely to appreciate the costs associated with your work.

A big part of the sale will be based on your expertise and knowledge. The customer needs to be shown what to do with something unique. Offering unique solutions can greatly benefit your business and push sales farther than you expected. Think outside the boundaries of tradition.

GALLERY-PRICED SALES AND PRESENTATION

In order to inspire in your customers the impression that your work is art, you will want to make sure you are at least in the right ballpark. Try visiting a local art gallery to get inspiration. Notice the treatment of the photo-

Providing customers with your expertise and knowledge will improve sales. Show them examples of gallery-style matting (top), or mats with multiple windows (bottom). Multiple windows, in particular, allow the customer to pair up photos that would not otherwise be enlarged.

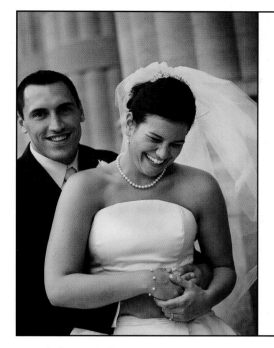

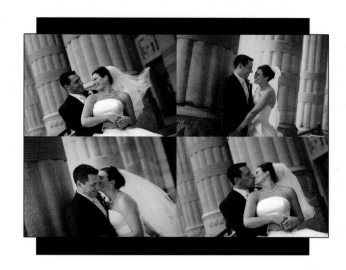

Digital albums (a flush-mounted album with a layered picture style) are gaining popularity and provide the more modern feel your clients desire. If you are doing your own layouts, try grouping photojournalistic photos by subject and mood in order to make them more desirable. These pages may give you an idea of how you can incorporate your photojournalism.

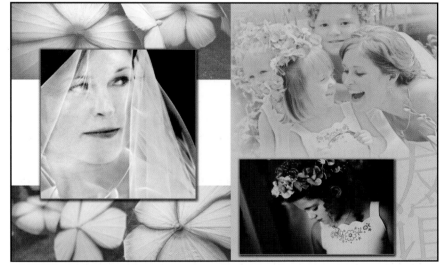

graphic images and the paintings. Present your images in the same manner, both in terms of the image design and the lighting strategies used to accentuate them. Put on a show. The drama created by doing this will only add to the impact of your images—and your clients' perception of their worth.

If you are going to sell your art, be prepared for the art world. The thought, care, and treatment that go into each image need to be applied to the price of the sale. Good art is not cheap. Setting your prices too low will make your work seem worthless. On the other hand, you mustn't set your prices so high (for your community) that your images are unaffordable and never make it to a living room. Find a balance, but make sure the price accounts for the difference between "any old picture" and "a work of art."

i do

Having these fine-art pieces on display in your studio will give your clients inspiration for their own wedding photos. They will see the displays and imagine what they can do with the photos they've purchased.

BECOMING A MEMBER OF THE FAMILY

After the wedding is over and the bride has received her album, don't let the relationship dwindle. In the wedding business, you have a unique opportunity to get to know the bride and her whole family pretty well. You get a chance to form a relationship with them and have them get to know you and your style quite intimately. You can use that relationship to your sales advantage.

Make sure that they know you well and they bond with you. If they like you, they will remember you. If they remember you, they will refer others and likely use you again for portraits in the future.

Also, keep in mind that the principals of advanced photojournalism can be applied to other genres of photography very effectively (see chapter 13 for one example). Let your customers know that your services are available for portraiture after the wedding. The bride and groom may already have children—or may be starting a family in the near future. It's not too early to give them the idea to come back, or refer others to do the same.

Advertise the post-wedding services you offer to them and keep in contact. You want them to feel like, on their wedding day, you became an honorary member of the family. If you can do that, you'll be first in their mind when it comes to photos in the future.

In a digital album, use the detail shots you created throughout the day to provide a break between pages and add your own unique style. You want to avoid a cluttered appearance with too many pictures in your album. If you offer only one version of each shot and it looks great, there are fewer options for the client, leaving you with a few great images that can be laid out in a more graphically pleasing way.

13. A Further Application

We have spent the majority of the book mastering the concepts of the decisive moment and educated instinct, opening up our minds to the possibility of self-projection into a situation. We have a firm understanding of the verbal and physical cues that help us define moments, and we know how to both anticipate and react to them. We understand the roles of both genuine moments and natural setups. Now that you know how to tackle a wedding in an instinctive photojournalistic style, I'd like to show you how to make these skills do double duty by applying them to photographing children.

CHILDREN'S PHOTOJOURNALISM

From a photojournalistic standpoint, children and weddings are very similar subjects. Both involve a great deal of action, and in order to photograph them well, you need to avoid interacting with the subjects. These kinds of portraits both demand that the subjects get to be themselves. There will be tons of activity and it's up to you to sort through the multitude of moments to find exactly the right ones.

All of the preparatory actions you took at a wedding apply here. Your camera needs to be ready at any moment, pre-focused whenever possible and preferably armed with a long zoom lens to allow for distance and privacy. Preparative thinking is an absolute necessity in these situations. Kids, unlike adults, do not care one bit about what you're trying to accomplish—in fact, if they display much interest in what you're doing, then you're likely attacking the situation incorrectly. In order for you to photograph photojournalistically, the subjects need to be virtually unaware of you. They need to be free to express themselves normally.

Children are immensely more emotional and acutely more aware of the world than adults. Therefore, photographing children in an emotional way

You always need to be prepared to move quickly, but children can move especially fast. They're not waiting for anybody.

is perhaps the most fitting way to capture their joy and mystification. Look for the emotional highs to present themselves. You are not just looking for a smile. You are not even looking for them to face you. You are recording joy, wonder, and intrigue—straight, raw emotion in action. Your goal is to capture a moment so charged with impact and resonance that it catapults the viewer back into their own childhood.

DISTRACTION

Before you can begin to shoot, the child needs to be secure with their surroundings and engaged in some sort of activity. The activity will attract their attention and provoke the kind of playful reaction you're looking for. I find that the use of toys and games gives me the freedom to both distract and entertain them. A playground makes a useful background and provides them with many different kinds of stimuli.

Having a parent present is helpful. The child will look for and talk to the parent, and the parent can, in turn, encourage the play and nudge them back into the right area when necessary. Additionally, parents know what will evoke responses from their children, so it's only logical to put them to work in this process. Invite them to be engaged in the playtime, and explain your process to them so that they can help direct.

With the parent involved, you shouldn't have to do any talking. The conversations should be between the parent and child, leaving you to simply observe, and allowing the child to forget your presence a little more. Think of it as witnessing a daily playtime. You are the onlooker, privy to a personal and intimate time. Capturing it in this way will bring home the kinds of images that really portray childhood for this family. Each family is unique, and this individualized, unscripted, unplanned method will allow them to be themselves.

The conversations should be between the parent and child, leaving you to simply observe.

Don't leave out the parents—if you notice interaction between them, shoot that too. Photojournalism is all about the moments of emotional interplay between people. Don't limit yourself to a single subject.

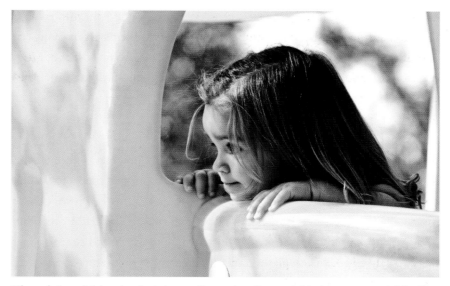

When doing children's photojournalism, shooting outside is non-negotiable. You need natural lighting and the children need to be able to move around. You will need natural backgrounds so that you are free to move about. Shooting at a local playground is ideal. It provides you with the needed space, amusement, and distraction for your little subjects. I find that a fill flash is nearly always necessary.

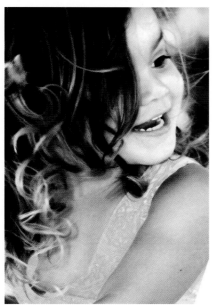

INTERACTION

To enhance the experience, key in on the interaction between mother and child, as well as the interaction between siblings. Photographing moments of interaction between parents and their children can result in some of the most simple and beautiful images you'll ever take. The unconditional love that you capture in a look or a gesture is timeless. Similarly, every parent wants to see their children happily involved with one another, getting along and sharing their learning experiences. They will be extremely grateful to you for capturing their children in these moments.

STIMULATING ACTION

In much the same vein as the natural setups we can use in wedding photojournalism, in children's portraiture, you, the parent, or the child can help stimulate the action in these photographs—then leave it free to develop as it needs to. This could be as simple as arranging to take the photos at a park, where you'll have access to slides, sandboxes, swings, flowers—anything they might enjoy. It will not only encourage play, and playful expressions, it will also lengthen the shoot and make it more enjoyable for the children. If they're having fun, they're likely to become repeat customers.

If playtime takes a downturn and high emotion turns to melancholy, your job is not necessarily over. Keep shooting, because you may be surprised by the result. A child quickly progresses from happiness to sadness, then right back to happiness. During this time, they are considering what

upset them and evaluating the situation. After the meltdown, they may be subdued and thoughtful. Children are all different, but each of them will probably show you a range of emotions. Be ready to accept the good, the bad, and the melancholy. There just may be more emotion in a quiet moment than there is in a joyful one.

CUSTOMER SERVICE AND SALES

Just as a modern bride is looking for a personalized product, so are moms. Mothers will be touched and overwhelmed by photos that show their child's true personality. Photos that touch them will be perceived as both timeless and priceless. If you can break out of the box of traditional children's photography, and do it with elegance and a polished finesse, your products should sell themselves to a happy mom.

If you remember to shoot for moments with emotional resonance, you will more easily connect with your client and viewer: Mom. To increase her desire, you need to create work that she will connect with. For you, desire means more products sold.

Remind yourself of all of the extra attention you provided to your bride. You worked with her to find the perfect album that fit her budget and personality. You discussed the type of work you shoot and the process by which you do it. She knew up front what you needed from her and what she would receive from you. Apply all of this knowledge to your new client. Mom will want an album, but what kind? What type of shoot is she interested in? Does she fully understand the photojournalistic style? Is she interested in artistic close-ups or an unusual presentation of prints?

You can also increase your sales to moms in many of the same ways that you did for weddings. A client won't know what is available to buy or have a desire for a product unless you show it to them. I've found photo jewelry to be some of the most personal items I can offer. Necklaces, earrings, or even purses are nice ways for moms and grandmas to show their affection. They are also an excellent add-on sale to any package. There are endless numbers of similar add-on items available, and you may even be able to create your own. Look for nightlights, paperweights, or unusual albums that develop your studio's style. Personalized framing options might also enhance your product line. Most importantly, include time for a consultation with Mom so that you can familiarize her with all of the products and services you offer.

Think of ways to make each portrait session a unique experience. Remember the mom's name and her son or daughter's name. Provide a thankyou card or great packaging upon pickup. Check in with them often and establish a relationship.

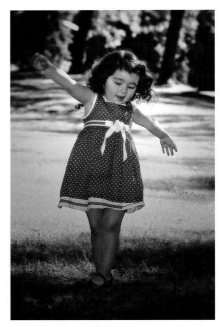

Keep an eye out for behavior that signifies childhood—or, more specifically, behavior that showcases the personality of the child you're photographing.

You can also increase your sales to moms in many of the same ways that you did for weddings.

EDUCATED INSTINCT

By now, your mind has been reset and your enthusiasm recharged. The philosophy of educated instinct is seeping in even now, and will continue to do so with more practice. You may still be reliant on your own reaction time, but as you learn to see the story that you're a part of, you'll start to instinctively know what to do and when to shoot. Shooting like an advanced photojournalist will become second nature.

Think of this style of photography as your new sixth sense. Adapt to it, and it will always be there. You'll begin to see these moments everywhere around you—especially as you put into play the tools we've looked at for predicting where and when they will happen.

You can practice using your new mindset almost anywhere. While waiting in line, listen to bits of the conversations taking place around you. Did you hear an "Oh my God" or some other verbal cue? Turn toward the source immediately and see what kind of reaction ensues. Create a mental picture of how you would frame the shot.

When you're at a family gathering or simply home with your kids, practice listening for anything that tips you off. Practice evaluating their expressions and reactions all the time. You can also go out in search of these moments at a coffee shop or restaurant. Sit alone and look busy with a book or a laptop while listening and watching how people move, when they react most forcefully and why. Look for behavioral nuances and physical prompts of ensuing emotion. Always be framing and calculating the shot in your mind. Get used to body language and the information it is constantly sending to you. Photojournalism epitomizes the "everyday," so it stands to reason that you can practice it every day, all the time.

You've taken the time to educate yourself on the decisive moment and how to achieve it. The hard work now is making it happen. Maintain your new mindset and look at the world through new eyes. Your new vision is not unlike that of a child, charged with emotion and open to every detail around you. Get ready to capture it—and to discover the wonder in everything.

INDEX

A

Add-on sales, 118

Adobe Photoshop, 105, 107–16

Anticipating moments, 37–44

Artistry *vs.* equipment, 20–22, 47–48

Aspect ratio, 109

Autofocus, 50

B

Background control, 78–79, 107–8

Black & white images, 107–8

Blue toned images, 110

Body language, 73–75

Bonnefoy, Yves, 47–48

Bride getting ready, 82–85

Bride's house, 86–90

C

Camera settings, checking, 59

Cartier-Bresson, Henri, 45–49

Ceremony, photographing, 90

Challenging yourself, 36

Children, 97–98, 121–24

Clients, 13, 16–20, 23–28, 115, 120

 connecting with emotions of, 23–28

 demands of, 13

(Clients, cont'd)

 educating, 16–20

 feedback from, 115

 personal relationship with, 120

 showing sample images to, 18–20

Composition, 11, 59, 67, 94

 framing elements, 94

Cross-processed images, 105

Crowds, working in, 59–60

D

Decisive moment, identifying, 23–28, 45–55

Depth of field, 67–68

Detail shots, 85–86, 93

Diptychs, 35

Distractions, minimizing, 59–60

E

Eavesdropping, 69–72

Educated instinct, 5, 45, 125

Emotions, 23–32, 37–44, 45–55

 anticipating, 37–44

 capturing peak, 28–32, 45–55

 connecting with the subject's, 23–28, 37–44

Empathy, importance of, 23–28, 37–44

Equipment, 20–22, 47–48, 50–54, 56, 79, 102–5

 accessibility of, 59

 digital, 102–4

 lenses, 79, 104, 105

 mastering, 50–54

 vs. artistry, 20–22, 47–48

Evaluating your images, 32–33

Experimentation, 105–6

Extraneous details, eliminating, 108–9

F

Family, extended, 101

Fine-art images, 111–15

Flattering your subjects, 54–55, 65–68

Flowers, 89

Focusing, 56, 59

Framed images, 35, 36, 113, 115

Framing elements, including, 94

G

Genuine moments, 78

Goals, setting personal, 32–36

H

Heirlooms, photographing, 87

I

Important people, 95–101

Instincts, honing your, 37–44

L

Lens selection, 79, 104, 105

Lighting, 78–79, 104–5

 control of, 78–79

 natural, 104–5

M

Mannerisms of key subjects, 77, 92–93

Matting images, 35, 36, 113, 115

Monotone images, 107–8

Multiple photographers, 13–16

N

Natural setups, 78–82

 background selection, 78–79

 for album images, 82

 lighting control, 78–79

P

Parents, 95–96

Patience, importance of, 61–68

Photojournalism, 6–10, 16–17, 121–24

 benefits of, 17

 further application of skills, 121–24

 goals of, 6–10

 limits of, 16–17

Portraits, photojournalistic, 65–68

Postproduction, 105, 107–16

 blue tone, 110

 cropping, 107–8

 cross-processing, 105

(*Postproduction, cont'd*)

 extraneous details, eliminating, 108–9

 monotone images, 107–8

 sepia tone, 110

 special effects, 110–11

 vignettes, 110

Practicing, 42–44, 50–54

Prefocusing, 56, 59

Preparation, 56–60

 camera settings, 59

 composition, 59

 gear, accessibility of, 56

 mind-set, 56

 prefocusing, 56, 59

Presentation techniques, 33–36, 111–15, 118–20

 diptychs, 35

 evaluating effectiveness of, 33–36

 fine-art presentations, 111–15, 118–20

 framed images, 35, 36, 113, 115

 matting, 35, 36, 113, 115

 triptychs, 35

Pricing, 118–20

Profitability, increasing, 116–20

 add-on sales, 118

 digital proofs, 117–18

 personal relationships, building, 120

 pricing, 118–20

 selling before the shoot, 116–17

 timelines, 117

Proofs, digital, 117–18

R

Reaction time, improving, 37–44, 50–54

Receiving lines, 63–64

Reception, photographing, 92

Relationship with clients, 23–28, 120

S

Sales techniques, 16–20, 116–17

Samples, showing to clients, 18–20

Second photographer, working as, 13–16

Sepia tone images, 110

Speed, *see* Reaction time, improving

Storytelling, 33–36

T

Timelines, maintaining, 117

Traditional photography, 13–14

Traditions, wedding, 75–77, 90

Triptychs, 35

V

Verbal cues, 69–72

 "I'm so glad you made it," 70

 "Oh my god," 71–72

 "That means so much to me," 70–71

 "You look so beautiful," 70

Vignettes, 110

W

Working unobserved, 10, 78–82, 104